The Ancient Art of Colima, Mexico

RICHARD D. REYNOLDS

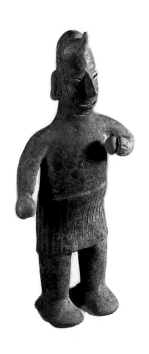

SQUIBOB PRESS INC.
WALNUT CREEK, CALIFORNIA

LIMITED FIRST EDITION: 1,000 copies

Published in the United States by:
Squibob Press, Inc., Post Office Box 4476, Walnut Creek, California 94596.

Photographs by Richard D. Reynolds
Cover Design by George Mattingly

Printed and bound in Hong Kong by Colorcraft, Ltd.

ISBN 0-9618577-1-4

Library of Congress Catalog Number: 88-92600

The author gratefully acknowledges the Bancroft Library, University of California, Berkeley; Jeannette Walter Ramirez; Wenceslao Olea; and María Ahumada de Gómez, whose help inspired every page.

Cover Photo: "Singer" from Cuahtemoc, Colima.
This unique Postclassic figure was found in a tomb on the southern flank of Volcán de Fuego. Approximate height: 19 cm.

Back Cover: "El Maestro." Unslipped buff.
H. 9.5cm., W. 7cm., L. 10.2cm.

Photograph of Volcán de Fuego by Wenceslao Olea.

Frontispiece and *Text Photos (pages 15, 18, 21, and 29)* from the María Ahumada de Gómez collection, currently on exhibit at El Museo de las Culturas de Occidente, Colima, Mexico.

9372799

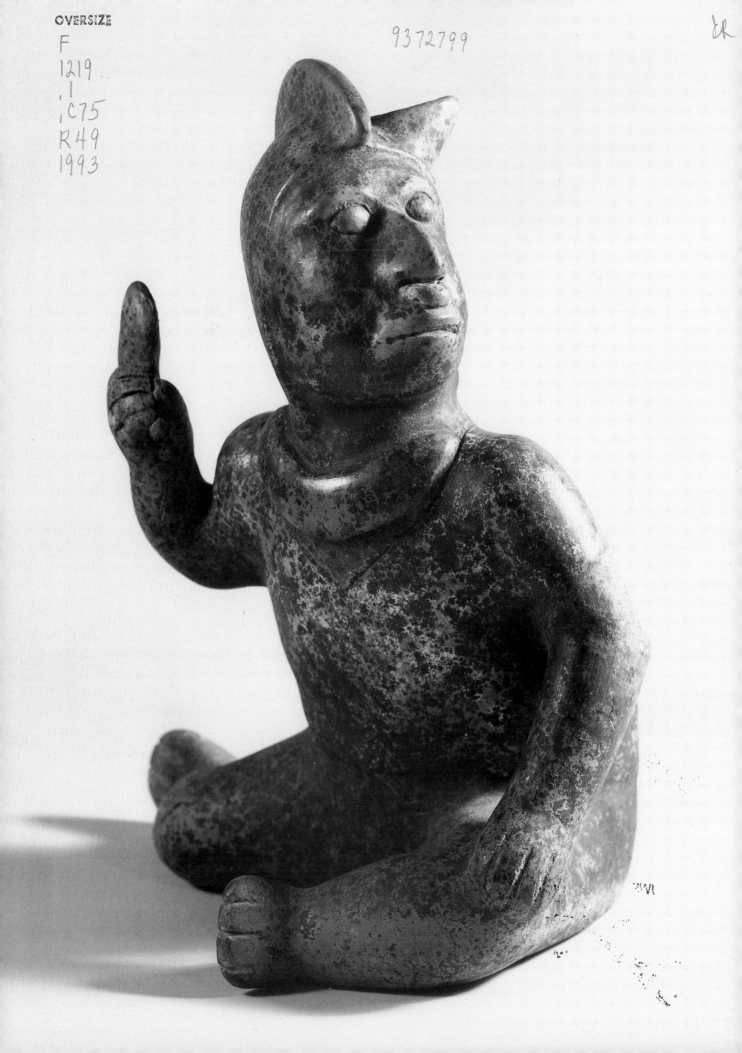

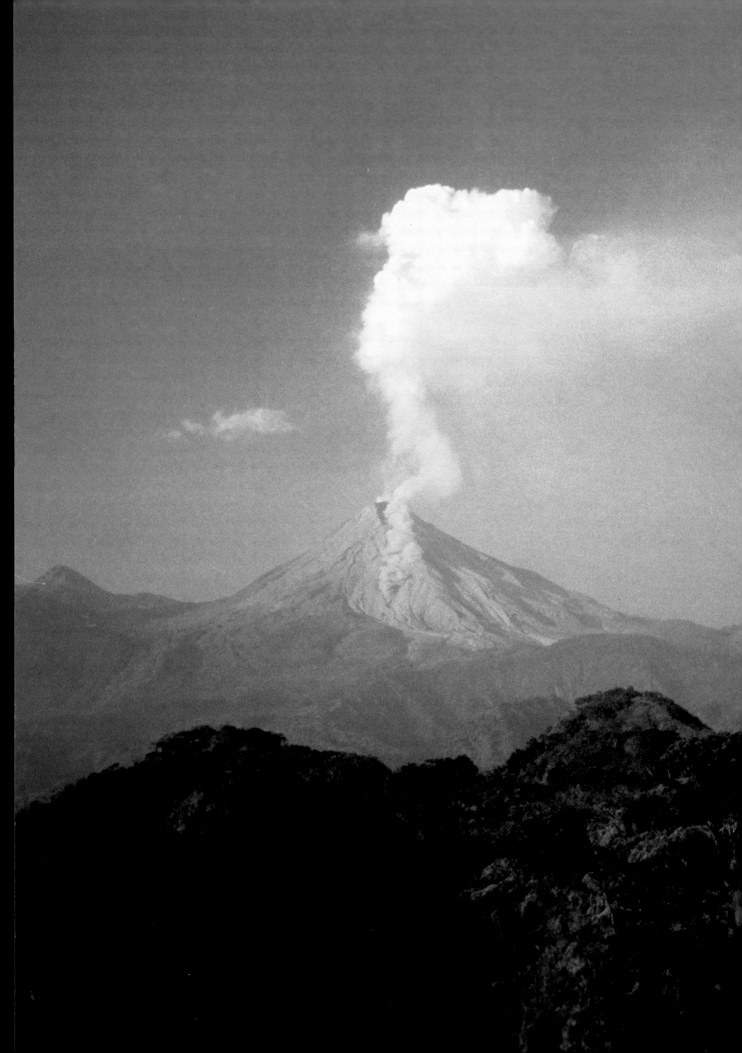

Foreword

"Oh, you should see the volcano in Colima! It's beautiful!" my friend from Mexico exclaimed. In April 1991, the Volcán de Fuego erupted, spewing lava and a plume of ash twenty thousand feet into the western Mexico sky in its most violent and awesome eruption since 1913.

News of the eruption carried me back to the first time I drove the narrow, winding road to Colima, almost twenty-four years earlier. How appropriate, I thought, that I should pull the maps and photographs of a long-forgotten book project from the chest where they had been hidden for two decades. As I stared at the glossy photographs on the kitchen table, memories of my dormant project to publish the private pre-Columbian art collections of Colima re-ignited like that pent-up volcano. The beautiful color photographs of the relics found in the ancient tombs of Colima had long since faded. But the black and white negatives of the funeral art were in the same pristine condition as the day I packed them, two decades earlier. I wondered if any of the art I had photographed in 1971 remained. I knew that most of the art, illicitly excavated from the tombs that dotted the countryside west of the volcano, had disappeared entirely from Colima and was now in the hands of collectors in the United States, Europe or Japan.

By November 1991, I was on the plane to western Mexico to see for myself the changes that twenty-four years had brought to Colima and the antiquities market. My former *novia,* Jeannette, met me in front of the hotel in Guadalajara, accompanied by her thirteen-year-old son, Juan Pablo. As we compared wrinkles and memories, I realized that if nothing else this trip was going to be an exploration of changes. When Jeannette and I first drove to Colima in December 1967, the highway was a narrow, sometimes dangerous road that snaked through a dozen small villages. American tourists generally weren't interested in traveling to a small provincial town like Colima. In 1967, the United States was preoccupied with the Vietnam war, California real estate was still cheap, and the "fabulous" Beatles were playing on the radio. Really, the only people willing to tackle the arduous road to colonial Colima were

the collectors of pre-Columbian art. Some of the truly great collectors
—such as Diego Rivera and Proctor Stafford—had already purchased
the most fantastic tomb offerings back in the 1940s and 1950s. In their
wake, aficionados of pre-Columbian art, like myself, invaded Colima in
search of undiscovered relics, looking for the elusive golden treasure.

In those days, the pre-Columbian art that inhabitants of this region
had fashioned more than a thousand years earlier was a little-known
treasure. By the 1990s, however, pre-Columbian art from western Mexi-
co had become a sought-after commodity, and today a modern *auto-
pista,* or toll road, connects Guadalajara with Manzanillo, Mexico's
largest Pacific port. On my return trip to Colima in November 1991,
Jeannette's car sailed across the dry lake beds and through the volcanic
mountain ranges that had always separated Colima from the highlands
of central Mexico. Miguel de la Madrid, the former president of Mexico,
had lavished his home province with federal projects, including a new
highway that took five years to construct. At times the project ran out
of funds as construction crews attempted to build towering bridges over
deep *barrancas* that rivers had cut into the soft, volcanic soil.

As Jeannette, her son and I drove west towards Colima, twin vol-
canic peaks towered above the new highway. The Nevado de Colima
was barren of snow because of a long drought, but as we drove over the
concrete bridge at Viaducto Beltrán, the Volcán de Fuego de Colima
belched ash a thousand feet into the afternoon sky. A slightly orange,
sulfurous smoke drifted down the sides of the volcano towards the city
of Colima.

When we finally entered Colima that night, I realized that the city
had changed so much that I barely recognized it. In 1967, the capital of
this tiny state was still recovering from a devastating earthquake, and
to a nineteen-year-old North American the town seemed like a hot,
sleepy little backwater village on the edge of nowhere. In those days,
Colima still lived in a slow-paced, colonial past, where on Thursday
and Sunday evenings the eligible bachelors marched ritualistically
around the town square and nodded to the young women of the town
as they passed. Now, on my return visit, the outskirts of Colima were
lined with new factories, and neon lights advertised discos on busy
streets. The economy was thriving with German and Japanese invest-
ment companies that had entered Mexico to capitalize on the region's
rich gold and silver mineral resources.

Circling the central plaza, we drove past the hotel where, in 1967,
a gentleman sold antiquities in an unpretentious room on the second
floor. I remember that the front room of his hotel suite looked like
the inside of an ancient tomb. Every shelf was covered with relics un-
earthed from the pre-Columbian tombs that dotted the flat, fertile

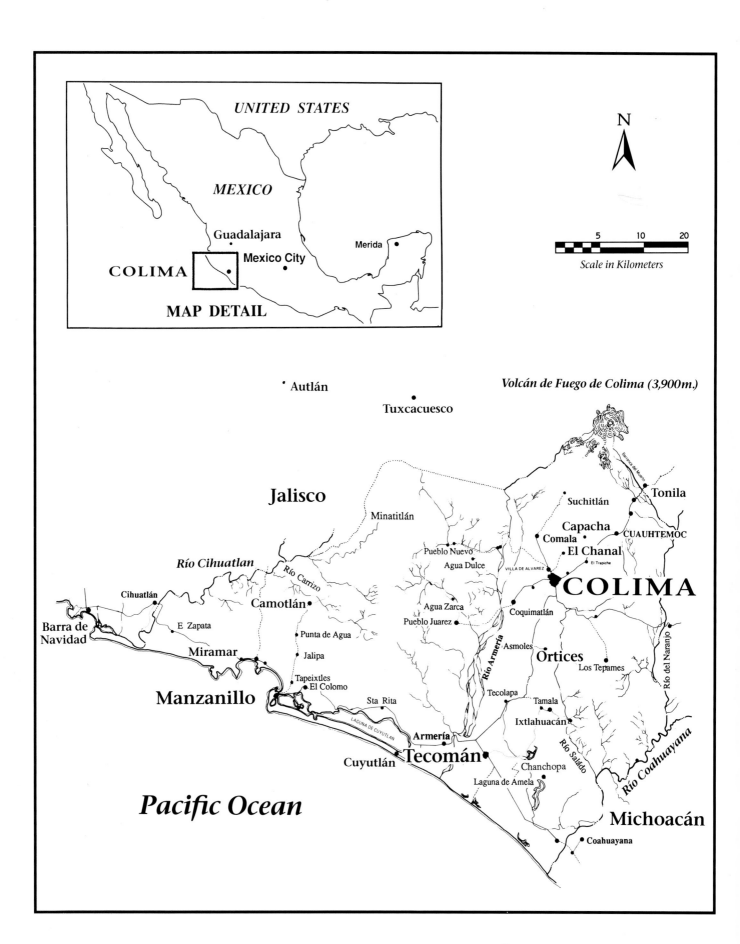

UNITED STATES

MEXICO

Guadalajara

Mexico City

Merida

COLIMA

MAP DETAIL

N

| 5 | 10 | 20 |

Scale in Kilometers

· Autlán

· Tuxcacuesco

Volcán de Fuego de Colima (3,900m.)

Jalisco

Minatitlán

Suchitlán

Tonila

Capacha

CUAUHTEMOC

Comala

Pueblo Nuevo

El Chanal

· El Trapiche

Agua Dulce

VILLA DE ALVAREZ

Río Cihuatlan

COLIMA

Río Carrizo

Camotlán·

Agua Zarca

Coquimatlán

Cihuatlán

Pueblo Juarez

E Zapata

· Punta de Agua

Asmoles

Ortices

Barra de Navidad

Jalipa

Los Tepames

Miramar

Tapeixtles

· El Colomo

Sta Rita

Tecolapa

Tamala

Manzanillo

LAGUNA DE CUYUTLAN

Ixtlahuacán

Armería

Cuyutlán

Tecomán

Chanchopa

Río Salado

Río Coahuayana

Río del Naranjo

Laguna de Amela

Pacific Ocean

Michoacán

· Coahuayana

countryside surrounding the town of Colima. There were grotesque funeral masks, exquisite anthropomorphic vessels and tomb figures shaped by potters more than a thousand years earlier. Everything was for sale—from the tiny gingerbread-styled figurines known locally as *tecos* that sold for a dollar, to three-foot high, museum-quality funerary objects. Standing in that apartment, I became an *aficionado* of pre-Columbian art and a devoted visitor of Colima from that day onward.

The region around the present state of Colima is unique. Although the ancient cultures of western Mexico never built the extensive pyramid complexes found in other parts of Mesoamerica, the early inhabitants of western Mexico were obsessed with a cult of the dead. The ancient cultures of Colima, Nayarit, and Jalisco buried their dead in deep shaft-chamber tombs, which were filled with rich funerary offerings, including delicate, highly expressive ceramic art. These shaft tombs are found nowhere else in Mesoamerica, and the freewheeling, naturalistic style depicted in the ceramic figurines is also unlike art from other areas. Indeed, tour books inform visitors that Colima, the state's capital, may have been founded in the eleventh century and called *Cajitlán,* the Aztec word denoting "where pottery is made."

In the absence of government-funded digs, most of what we know about the ancient culture of West Mexico comes to us by way of the art looted from the tombs by *moneros*—as seekers of *monos* or idols are known. I didn't know it then, but the genesis of my project to film the private art collections of Colima began with the first piece of art I purchased from the dealer on the central plaza. For the next two years I collected minor archaeological pieces and drove through the surrounding villages looking for art that farmers had found in their fields. I purchased ceramic trinkets, somehow missed or left behind by the big-time collectors. But the experience of viewing these ceramic remnants gave me a chance to see the impact foreign collectors of pre-Columbian art had made on the cultural history of Mexico. Regrettably, collectors of pre-Columbian art had spawned an industry of looters who were pillaging national archaeological sites throughout Mexico.

Carl Lumholtz, a Norwegian who explored northwestern Mexico by packtrain in the 1890s, was one of the first to comment on the wholesale ransacking of shaft tombs by looters (Lumholtz 1902: 304). In his book *Unknown Mexico,* Lumholtz reports having purchased large tomb objects, but laments that peasants often smashed ancient pottery in search of flakes of gold, and children sometimes used the ancient *terra cotta* figurines as toys.

Looting of the tombs in western Mexico continued at a steady pace, then exploded in the late 1960s when roads were improved. Suddenly it became fashionable to collect pre-Columbian art. Jules Berman, a Beverly Hills businessman, used his Nayarit collection to advertise Kahlúa, a coffee liqueur imported from Mexico. About this time, articles in business publications noted the fantastic upswing in prices, and suddenly big-name Hollywood stars like Natalie Wood and John Wayne invested in pre-Columbian antiquities. By 1970, collectors were willing to pay almost anything for authentic Mesoamerican art. An idol that cost ten dollars in Colima would easily bring two hundred dollars in New Orleans, Los Angeles or New York City.

As prices for pre-Columbian art escalated, the demand for it inspired an entire industry of pot-hunters, and a large segment of the rural Mexican population depended upon looted pre-Columbian art for their livelihood. When sources were depleted, many cemented broken fragments to sell to tourists or used ancient molds to manufacture forgeries.

The demand for pre-Columbian art by foreign collectors also encouraged looters to ransack many of Mexico's unguarded archaeological sites. Nothing was exempt. They stripped archaeological zones throughout Mexico with almost religious zeal. Thieves even burglarized the National Museum of Anthropology in Mexico City. In Yucatan, thieves routinely ravaged sites for artifacts, removed large monuments, or chainsawed façades and cut them into small, more saleable items. Some of this material was eventually sold to dealers in Germany, France, and Japan. Curators of museums in the United States also purchased purloined antiquities, although under Mexican laws all subsurface archaeological art was the cultural property of the state. For decades United States Customs welcomed antiquities and no duty was charged on items over one hundred years old. Even today, art dealers in the United States can resell the art at outrageous markups under the well-established rule of *lex locus situs,* whereby title is determined by the local law of the country where the property is located at time of transfer.

The conflict between looters and archaeologists trying to preserve the past is certainly not a problem exclusive to Mexico. In Arkansas, where American pot-hunters find dog effigies shaped by Mound Builders, state authorities have established a toll-free telephone number to report grave robbing of native Indian sites. But the looting of archaeological sites in Yucatan and the Central Plateau prompted Mexico to enact strict laws making it illegal to own and export the art. In 1971, Mexico formulated a law requiring all owners of pre-Columbian art to register their private collections. Mexico also pressured the United

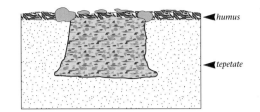
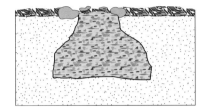
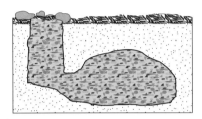
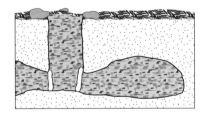

The four main types of shaft tombs found in Colima (after Disselhoff 1960, Figure 114).

Major Colima Phases (after Kelly, 1980)

1521	Spanish Conquest
1460	Chanal
1200	Periquillo
900	
690	Armería
600	
557	Colima
300 A.D.	Comala
0	
223 B.C.	Tuxcacuesco-Ortices
600	
900	
1200	
1870	Capacha

States and other countries to sign the UNESCO Convention which prohibited the illicit export of cultural property. The U.S. Senate gave preliminary approval to the UNESCO convention, and in 1972 Congress passed a law making it illegal to import cultural property stolen from museums or public monuments.

The new laws made it illegal—or least more difficult—to export pre-Columbian art from Mexico. As a result of the new reciprocal agreements, a few priceless artifacts found their way back to the National Museum of Anthropology in Mexico City. But, for the most part, the laws restricting pre-Columbian art were hard to implement and arrived too late to preserve the chamber tombs of Colima. By 1970, it was estimated that ninety percent of the tombs of West Mexico had already been looted and the art was in the hands of private collectors or museums. Practically none of it had been seen by a trained archaeologist.

Art from West Mexico was once considered a folksy, enigmatic substyle shunned by collectors of pre-Columbian art in favor of "higher" cultures from the Central Plateau and Yucatan. But this neglected status was changed in 1970 by an exhibit at the Los Angeles County Museum of Art of the collection belonging to Los Angeles businessman Proctor Stafford, who purchased his extraordinary tomb art during the 1950s, under the tutelage of Mexican painter/collector Diego Rivera.

The Proctor Stafford exhibit, which included spectacular figures from Nayarit and Jalisco as well Colima, was a brilliant, stunning achievement, and transformed pre-Columbian sculpture of West Mexico from folk art status. After the Stafford exhibit, no museum or private collection of pre-Columbian art was complete without a section dedicated to the clay tomb figures from West Mexico. The acquisition of the Stafford collection by the trustees of the Museum in 1986 clearly illustrates that some of the finest examples of art from the shaft tombs of western Mexico are no longer in Colima, but in the United States.

When I first saw the Stafford exhibit in 1970, I was torn between my love for primitive culture and the sick feeling that buying pre-Columbian art from *moneros* was a type of cultural "rip-off" and "plundering the past." I had seen the results of looting at various archaeological zones throughout Mexico and was aware that the seemingly endless supply of tombs dotting the Colima countryside was being sadly depleted. Staring at the Stafford collection, I decided to return to Colima and photograph the remaining private collections of pre-Columbian art in the state of Colima. Thus began this long-neglected project, which has taken so long to reach publication.

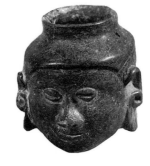

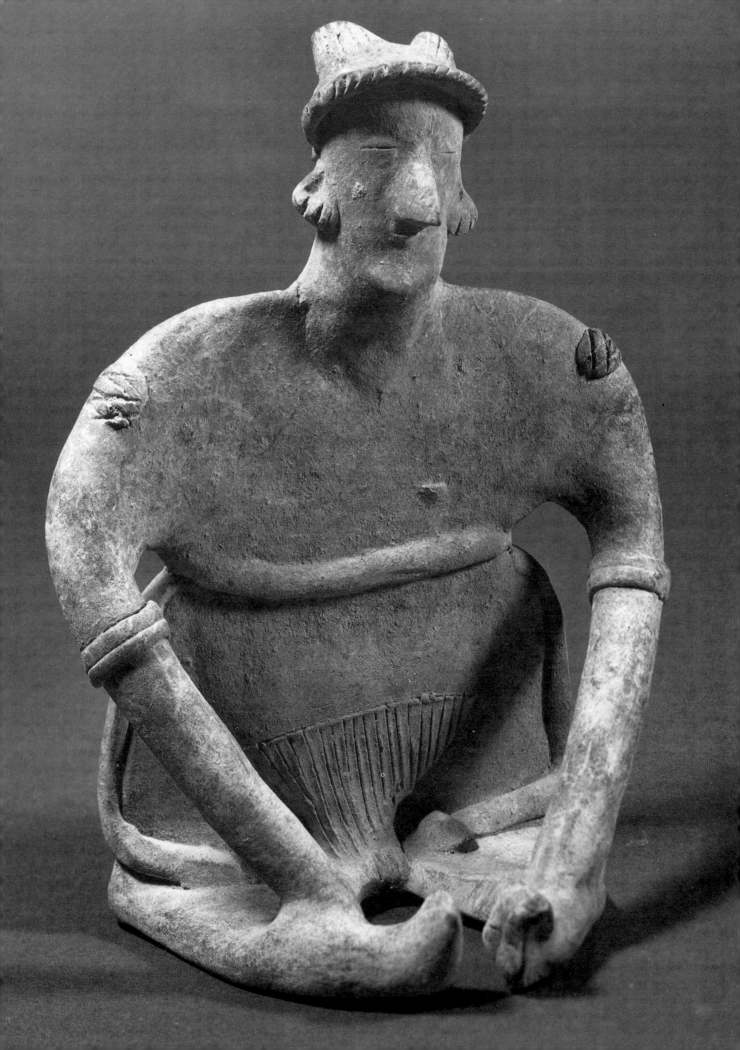

The project commenced with a meeting at the Los Angeles County Museum with Edward Cornachio, photographer of the brilliant Stafford exhibit catalog. Mr. Cornachio advised me on the proper equipment, lighting techniques, and depth of focus problems I was likely to encounter filming small bowls and tomb figurines. After several months of preparation, I returned to Colima in the summer of 1971, armed with a large-format Calumet view camera, hundreds of rolls of film, and a sense of determination to stay until I filmed the private art collections that I would encounter in Colima.

My first attempt at filming was a disaster. The unfiltered tap water in Colima was full of impurities that damaged the negatives, and electrical power for my portable studio lights failed with every thunderstorm. But my worst problem was dealing with the collectors. The individuals who had once sold me the precious art were now suspicious of my intentions.

In those days, it was easier to buy pre-Columbian art than to film it. Purchasing art is a simple, straight-forward matter. You pay the dealer in cash, wrap the sculpture in cloth, and slip out the door unnoticed. But to film these indigenous collections, I had to drag a heavy view camera, tripod, and an array of awkward lighting equipment into the homes of individuals who wanted to remain low-profile or anonymous. These collectors, who once considered me a friendly customer, now openly suspected that I was a spy, assigned by the government to locate and document their illicit collections. One even accused me of setting them up for seizure and confiscation. A few thought I was a fool—and to this day I sometimes agree with them. It cost more money to film the art than to purchase it, and I had the opportunity to purchase precious art at a fraction of what it was selling for in the United States. But instead of purchasing this beautiful, ancient art, I used my skills to persuade the collectors and dealers of Colima to let me photograph their "illegal" collections. Permission to film some of these collections was was granted only after long, tedious, diplomatic negotiation. In some cases, permission was never granted. But by December 1971 I had located and filmed approximately two dozen collections in every part of the state—from Río Coahuayana on the south to the border of Jalisco on the north. The collections ranged from broken artifacts belonging to a simple ranchhand to a horde of ceramic figures being sold to dealers in Guadalajara.

The most stunning collection belonged to Doña María Ahumada de Gómez. This superb collection of art was a lifetime achievement of a woman who acquired the looted art directly from *moneros* in an attempt to save the disappearing local history. Although she may have deplored the damage done by the *moneros,* Sra. Gómez was fascinated

by her culture and wanted to preserve it. She was also a pragmatist, who knew everyone in "the business"—collectors, *moneros,* and archaeologists alike. This remarkable woman was not deterred by the lack of government funding. Sra. Gómez purchased funerary offerings from the *moneros* out of her own pocket and single-handedly put together the collection that later formed the basis of the regional museum. She bought every object she could afford—including rare gold and metal objects, exquisite ceremonial figures that adorned the princely tombs, unusual *Tlaloc* urns uncovered by looters in El Chanal and Postclassic figurines from Tecoman.

The María Gómez collection consisted of large funerary pieces found during the 1950s when art from the tombs was cheap and largely authentic. Her competition in those days was from ardent collectors such as Mexican artist Diego Rivera, collector Kurt Stavenhagen of Mexico City, and businessman Proctor Stafford of Los Angeles, who ventured over the flanks of the volcano in the 1950s to accumulate some of the most spectacular collections of pre-Columbian art in the world. But proximity to the source of the chamber tombs meant that Doña María often had the "right of first refusal" for some of the most stunning art ever to come onto the antiquities market.

When I first met Doña María Ahumada de Gómez and filmed her collection in 1971, it was known as El Museo Regional de Colima and located in her private home. Today, her collection fills two floors of the state-owned-and-operated museum, and has been renamed El Museo de las Culturas de Occidente. The vast collection belongs to the government now, but the strong personality of the late Doña María Ahumada still permeates the collection, and many of her handwritten descriptions still remain with the objects. Her collection begins with the "Capacha," a cultural style classified by noted West Mexican archaeologist Dr. Isabel Truesdale Kelly as the earliest period in Colima. In addition to early Capacha-style pottery, the collection includes gigantic head pots and stirrup bowls reminiscent of South American cultures. Other periods permanently on exhibit at the museum include *Tecos* from the Ortices phase, classic Comala ceramics, and a wide variety of Postclassic representations.

Much of the archaeological data concerning Colima comes to us from Dr. Kelly, a pioneer in a region practically devoid of state-funded archaeological expeditions. In the 1940s, she retraced Francisco Cortés' *visita* to Colima and located many of the aboriginal towns named in the *Suma de Visitas* and in the 1579 *Relación de Amula, Tuxcacuesco, y Cusalapa.* Dr. Kelly followed the Armería River as

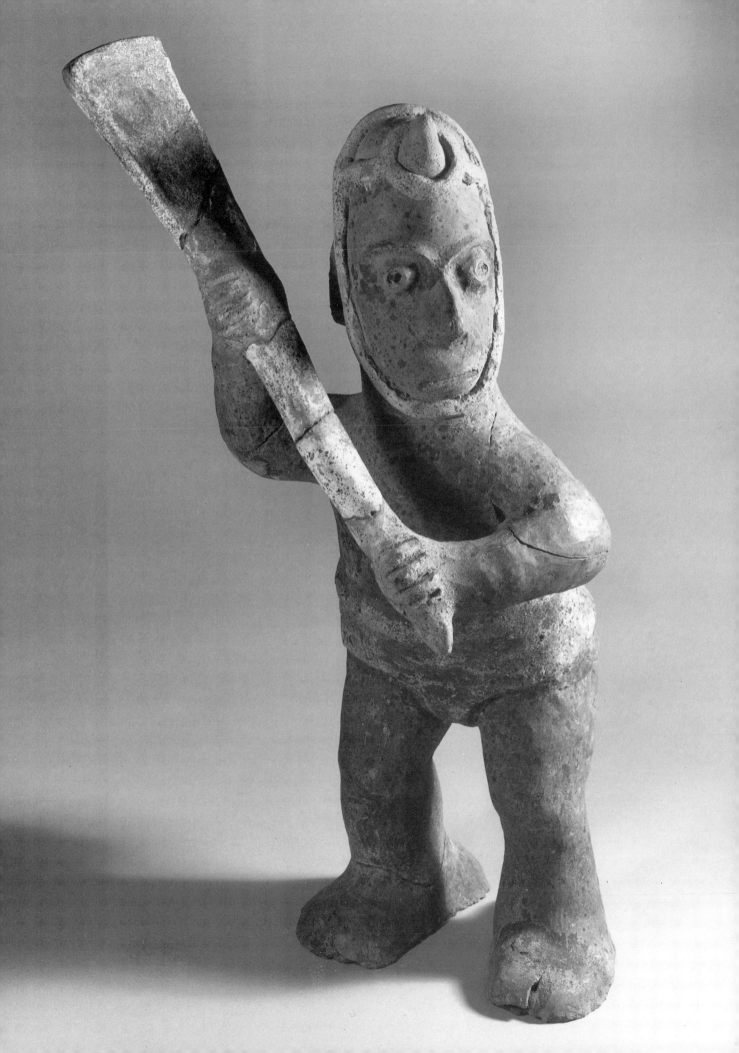

it flowed from Jalisco above the volcano southward to the Pacific and surveyed almost the entire state of Colima and the adjoining state of Jalisco. The *Relación* embellished the natives with great wealth, but Dr. Kelly's surveys indicated that the population generally lived in mud-daubed, cane-thatched domiciles, and were probably presided over by an elite circle of rulers who were constantly at war with one another.

Dr. Kelly excavated at Los Ortices, in central Colima, and also in the Autlán-Tuxcacuesco-Zapotitlán zone of Jalisco, at the headwaters of the Armería River. In one of her reports, published by the University of California Press in 1949, Dr. Kelly noted that the terrain near the Volcán de Colima was so difficult that neighboring villages often spoke different dialects, and there were pockets of relic populations of unknown origin. She found that the tomb art of ancient Colima was not homogeneous, but rather an amalgam of diverse styles—which she eventually classified as the Tuxcacuesco-Ortices, Comala, Colima, Armería, Periquillo, and Chanal phases. Years later, Dr. Kelly added an earlier phase, which she termed the Capacha.

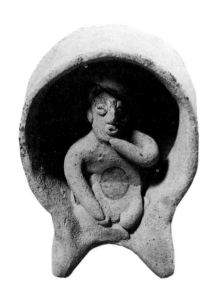

In her report, Dr. Kelly mentions the discovery of a thin orange vessel found in the dirtfill of a looted tomb at Chanchopa, near Tecoman (Kelly 1949:195). This Teotihuacán-style vessel tenuously established a time correlation between the West Mexican shaft-chamber tombs and Classic Teotihuacán in Central Mexico. But many ceramic phases of Colima, particularly along the coastal regions, showed few influences from the Central Highlands, suggesting that the region west of the volcano may have been cut off geographically and culturally from the rest of Mesoamerica. Even the Comala phase, which Dr. Kelly termed the era of shaft tomb *par excellence,* lacked any apparent influences from its contemporary Teotihuacán, which she found puzzling. She surmised that perhaps the potters of Colima were preoccupied with their own "Comala red" and thus unreceptive to outside influences. Or perhaps present-day looters had eliminated all evidence of contact (Kelly 1980: 7). Another possibility was that the rugged, volcanic terrain and deeply eroded canyons may have impeded the diffusion of trade from the Central Valley of Mexico.

For decades scholars have speculated why the ancient cultures of western Mexico lack many of the central features of urban development. They also wonder why the region seems to have evolved differently from the rest of Mesoamerica. The "high" cultures of Mesoamerica were obsessed with building pyramids to their pagan gods, but this feature is missing from classic Colima. There is also no surviving evidence of hieroglyphic writing systems within the state of Colima. Yet the region of far western Mexico was unique for burying its dead in deep

shaft-chamber tombs, which were filled with ceramic treasures to accompany the dead on their journey to the underworld.

The shaft-chamber tomb complex appears not only in Colima but also in the neighboring states of Nayarit, Jalisco, and parts of Michoacán. Dr. Kelly noticed similarities in the ceramic material she had collected from the mouth of the Río Armería to that of the inland regions, and hypothesized that there was a continuous zone of "chamber tomb" culture from the coast of Colima northward into the "Nayarit hinterland." Except for this western region of Mexico, this feature of burying the dead in deep chamber tombs appears nowhere else in Mesoamerica.

But Dr. Kelly noted that chamber tombs had been encountered in Ecuador, and speculated that western Mexico may have been a "way station" for traits transmitted by sea from South America. In addition to burial practices and the practice of cranial deformation, similiar ceramic techniques such as resist painting, and examples of head pots and stirrup pottery found in the Mexican chamber tombs strengthen the possibility of trade with South America in ancient times.

In 1969, Dr. Kelly established a dateline that supported this early South America theory. She persuaded a *monero* to take her to a partially excavated pit in Capacha, a few kilometers north of Colima, and watched as he extracted the fragments of a large, monochrome, cinctured vessel, known locally as a *bule,* or water gourd. The *bule,* with its distinctive sunburst motif, was similiar to a style Dr. Kelly had encountered years earlier at Los Ortices, southwest of the city. She identified the specimen as contemporaneous with the Mesoamerican Preclassic, and named this special ceramic assemblage "Capacha phase" after the cemetery brought to her attention by the looters. This simple ceramic bowl—unsaleable by dealer standards—pushed the early occupation of Colima to 1870 B.C., a date that preceded the Olmec culture on the Gulf Coast. Furthermore, the vessel established a dateline that could support a possible South America theory. Capacha may have been a "way station" for cultural influences from northwest South America, which pushed inland to other coeval sites, such as Tlatilco (Kelly 1980:37).

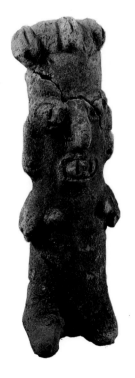

T he spectacular hollow art found in western Mexico's unique shaft tombs tended to focus on human, almost secular, domestic village scenes. This was a village society, and nowhere was this more striking than in the art depicted by the ceramics and large funerary offerings found in the tombs west of Volcán de Fuego. In contrast to the ritualism of the Central Plateau, the ceramic artisans of Colima were not

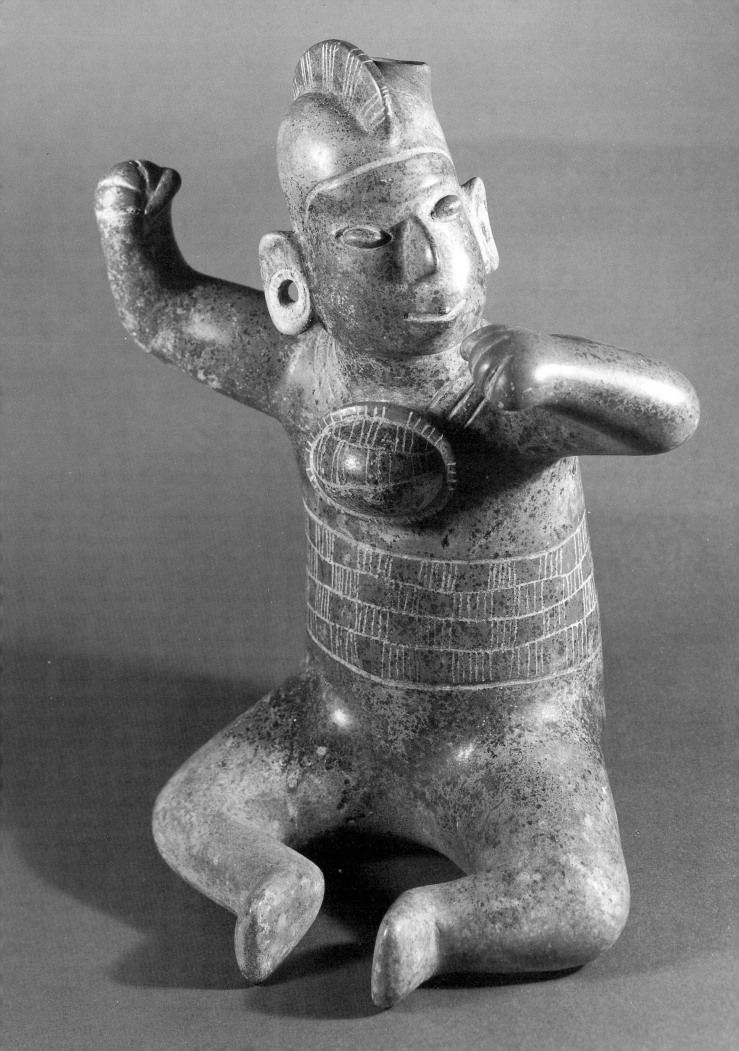

limited to a religious or ceremonial iconography. Rather, they portrayed their natural environment and transformed ordinary bowls into powerful ceremonial offerings with personal as well as religious connotations. Whereas deities dominated the art of Central Mexico, the ancient artists of Colima often illustrated scenes from everyday life—pregnant women, lovers caressing, children laughing, or dwarfs begging for food. The world was a magical place, but unlike their counterparts in the highlands, the ancient potters of Colima seemed to represent man in union with his environment. Babies suckling at their mother's breast were sometimes represented as starfish, and it was not unusual for the Colima artist to portray real joy or anguish in the faces of their subjects. Women cried, children squalled, villagers danced arm in arm in circular celebration. Misery, pain, and pathos in the faces of the infirm, or the dying were also depicted.

Of course, there are differences of opinion concerning the meaning of certain reoccuring images such as the dwarf or the horned warrior. Peter Furst, for example, believes that western Mexico's seemingly "mundane" tomb sculpture is, in fact, complex and ritualized (Furst 1978:26). How else can you explain the bizarre depiction of anthropomorphic shark monsters, animals transformed into dogs, figures with trance-like expressions, grotesque hunchbacks, and double-headed snakes? Furst believes that "virtually every creature depicted in the funerary art of the shaft tomb cultures repeats itself in Huichol symbolism..." (Furst 1978:27). In his opinion, the horned warrior has magical connotations, and the dwarf, so commonly depicted in the chamber art, may represent a shaman who interpreted and linked man with the swirling netherworld.

During the apex of the culture, the shaft chamber burials were accompanied by anthropomorphic effigy vessels and zoomorphic representations of animals, birds, and vegetables common to the region. One of the favorite representations, and one often found in the tombs in Colima, was the domesticated edible dog—generally known by its Nahua name, *xoloitzcuintli*. The dog is commemorated in the ancient village of Ixcuintlan, west of Autlán (Sauer 1948:82), and locals still sometimes refer to the animal as an "escuintle." *Relaciónes de los Motines,* published in A.D. 1580, reported that this particular breed had very short hair, grew fat with little feeding, and was eaten during special feasts. In Mesoamerican mythology, this dog may also have been a servant of lightning and thunder. Other anthropologists have suggested that it was a guide who ferried his master's soul across the River of the Underworld. Whatever its meaning, an entire section of the Museo de las Culturas de Occidente is devoted to the Colima dog. Visitors can

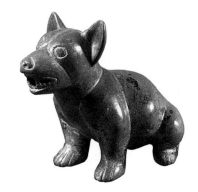

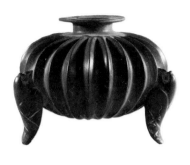

marvel at dancing dogs, dogs with human faces, and dogs resting at the feet of the dead.

When not obsessed with the magic of their universe, the culture of Colima and the western region seemed obsessed with the cult of the dead. The shaft-chamber tomb was central to the Colima culture, and it appears the tombs were used and reused for centuries by succeeding generations—which might explain the mixture of styles and periods within the same tomb. The mortuary chambers were filled with vessels representing fruits, animals, and parrots that may have contained food or liquids to accompany the dead. The tombs also contained figurines which may have represented servants to assist the dead on their journey through the spirit world.

Some of the offerings are so bizarre that we will never know their precise meaning. Other figures seem to represent chieftains, warriors, or even ball players. The existence of a ball court at El Chanal indicates that Colima, though isolated, may have participated in the Mesoamerican ritual ball court.

The art of Colima underwent great changes in the later periods. The tradition of shaft chamber tombs disappeared, and ceramics from the Colima and Armería phase, dating from A.D. 600 to A.D. 1100, mark an artistic shift towards more simple, cream-colored pottery decorated with geometric designs. Figurines belonging to the Periquillo phase, centered along the lower Armería, were unique for their depiction of extraordinary noses. After the demise of Teotihuacán, western Mexico was inundated with Mixteca-Puebla influences, but Colima remained largely isolated (Kelly 1980:10). Contact with South America may have persisted, however, and metallurgists from South or Central America may have been responsible for the sudden appearance of metallurgy in Colima between A.D. 700 and A.D. 900.

The rich, wildly eclectic María Gómez collection includes sculpture exhibiting the changes in the region's ceramics, as Central Mexican influences entered Colima during the Postclassic period. The most interesting tomb offerings from the Postclassic period were from El Chanal, along the base of the volcano. This important site, some 8 kilometers north of Colima, was apparently used as a burial site from the Classic period almost until the time of the Spanish Conquest in 1521. Postclassic wares from the El Chanal phase (A.D. 1200 to 1500) show uneven but distinct cultural influences from other regions of Mexico. For the first time, pyramids and stone monuments were built, although not on the scale found in the Central Highlands. Tomb figurines incorporated various Central Mexican motifs, and reliefs of the rain god *Tlaloc* appeared in stone for the first time.

Tombs from El Chanal often contain molds, as well as large, gray

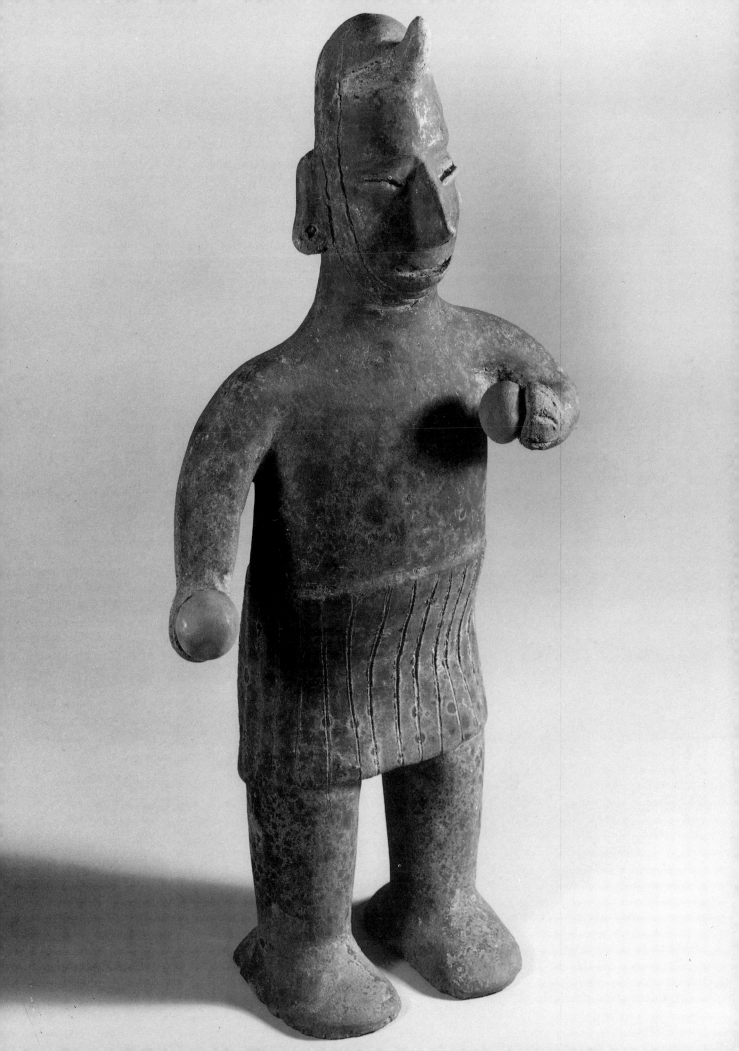

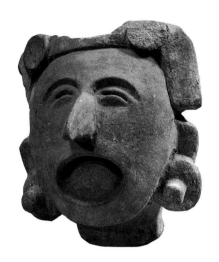

incense cylinders with saucer-shaped eyes. These urns are sometimes covered with representations of *Tlaloc.* Dr. Kelly notes that "Tlaloc-like" urns, and other ceramic traits seem to reflect Tula-Mazapan influences from the Central Highlands and may be the result of wandering tribes dislocated by the collapse of Tula, in A.D. 1156 (Kelly 1980:14). In addition, large standing figures, commonly known as "singers" appear in El Chanal and are also found in the vicinity of Cuahtemoc, along the border of Jalisco. Some have suggested that these are female representations of the deity *Xipe,* and that the uplifted hands and pointed headdress vaguely resemble the "Smiling Faces" of Veracruz (Kelly 1980:12).

After viewing the Museo de las Culturas de Occidente,we drove up a cobblestone lane towards El Chanal, on the southern slope of the volcano. At the cemetery are the remnants of a ceremonial ball court and several pyramids dating from the Postclassic period. An eight-foot chain link fence, topped with barbed wire, surrounds this "important archaeological" site. But the fence was erected four decades too late. The area surrounding El Chanal is today a rubble-strewn no-man's land, pitted and scarred by haphazard trenches dug by *moneros* looking for as yet undiscovered tombs. What was left of the ball court had been converted to a dusty soccer field used by the local youths.

"There used to be a pyramid there," a native said, "but somebody stole it."

The spectacular prices for pre-Columbian art and the severe poverty of rural Mexico meant that many farmers were at least part-time *moneros,* who supplemented their incomes by supplying collectors with funerary art they found in the tombs. Nowhere was this clearer than in the cemetery of El Chanal, where gold artifacts were found and dealers would present themselves "every afternoon, with full purse and accompanied by armed guards."

In fact, as Dr. Isabel Kelly noted grimly, some of the *moneros* made more money on one of their digs than her entire season's budget, and some had logged more "dig time" in the trenches than she herself. In her monograph *Ceramic Sequence in Colima: Capacha, An Early Phase,* Dr. Kelly relates how she met one *monero* who boasted he had "excavated" close to 400 tombs, and she confesses that he was almost a greater authority on Colima art than the *grand dame* of Colima archaeology herself (Kelly 1980:1).

Although she despised the destructiveness of the *moneros,* Dr. Kelly was a realist and understood that the looted relics were a resource that a specialist on Colima could not ignore. The chronology of Coli-

ma was bound to be "a thing of shreds and patches," and Dr. Kelly learned in the 1940s that it was sometimes easier to buy the art from the *moneros* than to find sponsors for a funded survey. Much of the budget for Dr. Kelly's first three seasons at Autlán-Tuxcacuesco was paid by her colleague Carl Sauer, who generously shared his salary with the young archaeologist (Letter, from Isabel Kelly to Alfred L. Kroeber, 14 March 1943, Alfred L. Kroeber papers, Bancroft Library, University of California, Berkeley). Dr. Kelly complained that the rest of her precious research time was wasted haggling with maids, fixing tires, or traipsing to Mexico City to extend her visa.

So, in the end, even an archaeologist like Dr. Kelly was forced to purchase artifacts and use informants who had looted the graves to recreate the chronology of the region. Dr. Kelly's data often included the pot shards left behind by the *moneros* who had looted the rich cemetery sites above Colima, and her discoveries were sometimes supplemented by the the purchase of specimens from locals, who knew the region better than anyone. Dr. Kelly's flexibility ultimately led to her success in identifying the "Capacha phase," the earliest period in Colima's chronology.

After leaving the destroyed archaeological site of El Chanal, we drove to the home of an old acquaintance I had met on my first visit to Colima in 1967. My friend's hair was now gray, and he had recently retired after many years as a schoolteacher in Colima. Everyone in Colima knew "Lalo." Two decades earlier, it was Lalo who introduced me to María Gómez and who took me around to the various private collectors in the state.

As we walked up the street in modern Colima, Lalo pointed out the birthplace of Miguel de la Madrid, where the ex-president of Mexico lived until his father, a well-to-do attorney, was reportedly murdered by a business associate. Then we reached the plaza and walked past the old Casino Hotel, which had been converted to a cultural arts center. The ground floor was now a museum for pre-Columbian art recently donated to the state by ex-governor Lic. Francisco Velasco Curiel. The collection consisted of tomb sculptures, including fattened dogs that the governor had acquired two decades earlier.

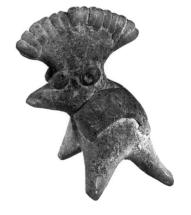

Lalo used my visits to better acquaint himself with his culture. But even twenty years ago, it was getting harder and more expensive to find authentic pre-Columbian art. Personally I knew it was only a matter of time before the art of Colima would be gone forever.

"Oh, there will always be more," I remember Lalo telling me. But Lalo was wrong. Twenty-four years ago you could buy an authentic,

Tuxcacuesco-Ortices-styled figurine for ten pesos—or less than a dollar. Now the merchants were selling shoddy-looking replicas for ten times that amount.

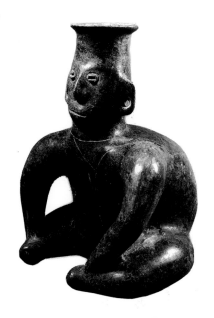

After viewing the ex-governor's collection on the plaza, we drove southwest to Los Ortices, in central Colima, one of the richest archaeological zones in the state. We followed the signs from the main highway to the archaeological zone, and arrived at the Hotel Tampumacchay, a resort built on the ridge overlooking the Ortices River. The walkways were lined with hundreds of stone *metates,* and the grass lawn served as an open-air museum with carved stone idols that workers have found in the vicinity and fossils of woolly mammoths that once roamed the region thousands of years ago. After inspecting a glass showcase which displayed bowls, idols, copper jewelry, and obsidian knives, we went to the restaurant, which had a commanding view of the deep, cactus-covered canyon cut into the volcanic soil by the meandering Río Ortices.

The lava-rich countryside of Ortices is dotted with ancient burial tombs and these deep, vertically shafted, subterranean tombs yielded some of the finest effigy vessels ever found in Mesoamerica. Hotel guides are available to take tourists to see some of the looted tombs in the nearby countryside, where Dr. Kelly excavated in the 1940s. But the shaft tombs of Colima do not have the glamour of a Hollywood movie, and they are not the spectacular curse-ridden crypts that Indiana Jones, the archaeologist/adventurer explored in *Raiders of the Lost Ark.* Some of the shaft chamber tombs of Colima that remain are mere rock-lined slumps in the dusty soil. Nearly all have been looted decades earlier, and many of those have been filled in to prevent cows and villagers from accidentally falling into them.

As we walked back from the hotel to the car, I noticed *"Se Vende"*—for sale—signs on the dusty, scrub-covered ridge overlooking the Río Ortices. Here, on the edge of nowhere, an enterprising real estate developer had surveyed and parceled out one of the richest archaeological sites in Colima into neat little residential lots. The future subdivision was called "Las Animas," perhaps because of the rich representations of birds and animals found in the ceramics of the ancient tombs.

From Ortices, we drove west to Tecoman, a modern city located among the coconut plantations of the coast. Tecoman was an important urban center at the time of the Spanish Conquest, and ar-

tifacts from this region show the rich diversity of regional styles within the state of Colima.

Lust for precious metals brought the first Spaniards to Tecoman, which in ancient times was closer to the coast. Almost immediately after the conquest and destruction of Tenochtitlán in 1521, the Spanish conquerors launched a combined sea and land assault on the western states of Colima and Michoacán, which they believed were the source of the Aztecan gold. In 1523, Gonzalo de Sandoval marched up from what is now Acapulco to secure the region, and Spanish *Conquistadores* eventually subdued the coastal tribes of Colima near Tecoman. The Spaniards then moved inland, and for a very brief period, the Villa de Colima was an important outpost in the conquest of New Spain. The mines of Colima were believed to be so rich that Hernán Cortés staked out the best portions for himself, and he selected his cousin Francisco Cortés as the first *alcalde mayor* of Colima. The province was promptly divided up among the Spanish soldiers and caballeros, who forced their Indian *tributarios*—men, women, and children—to work in the gold and silver mines located in the deep ravines beneath the volcano and along the southern coast, in the provinces of Coalcomán and Motín. Within fifty years of the Conquest, disease and mistreatment by the Spanish conquerors had decimated some eighty percent of the Indian population. Without the native labor pool, the producing mines were abandoned and Colima again retreated to its quiet, almost isolated, colonial status.

Today the ancient village of Tecoman, on the southern coast of Colima, is the world's largest producer of oil-of-lemon extract, and is a major copra production center. There is no official museum, but in 1971 I photographed the collection belonging to a woman who hoped to start one. She kept her collection in a garage-like storage room, and it was filled with a particular style of crudely fashioned figurines which Carolyn Baus Czitrom has labeled "Tipo XX, Figurilla Periquillo, Nariz Adornada," in her monograph *Figurillas Sólidas de Estilo Colima: una Tipología* (1978:110).

The collection I photographed in Tecoman was—like the tombs themselves—eclectic and included art from neighboring districts. *Moneros* brought her pre-Columbian relics found in the rich burials along the Río Coahuayana, which flowed from the mountains through the tropical lowland. As I dug through a cardboard box where the woman kept some of her idols, I made an incredible find. At the bottom of the box my fingers retrieved a dark green, highly polished jade Olmec mask, approximately two inches in diameter.

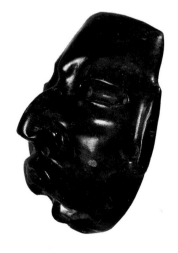

The collector, who had relegated this piece to the bottom of her cardboard box, was unaware that this was possibly the most valuable

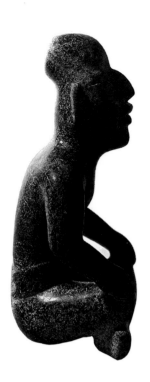

find in her entire storeroom. The piece didn't belong in Colima at all, but rather in the steaming jungles of southern Veracruz or Tabasco. Nor was it an isolated find. As I moved from town to village filming the catalog, I soon encountered several Olmec sculptures, reportedly found in the Río Coahuayana region.

Archaeologists have always assumed that the village people of western Mexico were isolated from the rest of ancient Mexico. Many believe that the culture of Colima, located in the shadow of the great volcano, was outside the mainstream of Mesoamerica and failed to achieve the level of high culture which dominated other parts of Mexico and Central America.

Ignacio Bernal wrote in *The Olmec World* (1969:143) that western Mexico and the region north of the Río Balsas evolved differently because they lacked contact with the Olmecs, the great mother culture that flourished in the humid Gulf Coast during the first millenium before Christ. "Not having the civilizing influence of the Olmecs," he wrote, "western Mexico remained permanently backward, a situation which began to alter only many centuries later with the establishing of the Tarascan empire in the Fifteenth Century."

Although I encountered Olmec sculptures in Colima, I have eliminated them from the catalog because they belong to a style and culture considered "foreign" to the region. Nonetheless, the appearance of Olmec in Colima is certainly tantalizing, and an archaeologist may someday uncover a great cache of Olmec sculpture in the unexplored region along the Río Coahuayana.

It was November, and it wasn't supposed to rain. But on the last night of our tour of Colima a tropical storm swept in from the ocean, and lightning streaked across the sky and lit up the jungle. In the darkness, the waving palm trees looked like windmills.

It rained torrents that night, and the next morning as we left Colima the roads were freshly washed. We had been in Colima for only four days, and yet when we left the highway to Guadalajara had changed completely. The previously dry lake beds along the *autopista* were now brimming with water, and the twin peaks of the volcano were capped with a fresh frosting of snow. Even the tolls on the *autopista* had increased.

Nothing ever stays the same. People die. Cities grow up. Resorts fade and disappear into the sand. After twenty years I barely recognized the city that was once a colonial town on the edge of nowhere, where people were friendly and you could buy authentic pre-Columbian art for the price of a transistor radio.

The Ancient Art of Colima, Mexico

And yet some things are eternal. The volcano was still smoking, as it had for thousands of years. The art from the ancient tombs was as beautiful and expressive as the day an artist molded it seventeen hundred years ago. Colima was modern perhaps, but the city was still immaculate and the people still friendly. And it was nice to learn that every Sunday, when the orchestra plays, the eligible bachelors and girls of the city still promenade around the plaza.

As for the private art collections of Colima, most of the art I photographed in 1971 had disappeared, or had been purchased by collectors in the United States, Europe, and Asia.

Maybe it doesn't matter. It is consoling to know that the magnificent collections belonging María Gómez and the ex-governor are now in state museums, to be enjoyed by everyone. And the photographs in this catalog at least document—on film—the richness of the private art collections of Colima before they were traded and sold to foreigners and scattered across the globe forever.

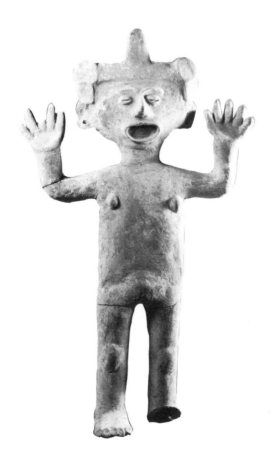

Selected Bibliography

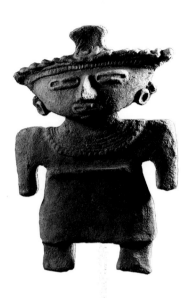

Alsberg, John L., and Rodolfo Petschek
1968 *Ancient Sculpture from Western Mexico: The Evolution of Artistic Form:* Berkeley: Nicole Gallery.

Artes de Mexico
1960 "Anahuacalli. Museo Diego Rivera." *Artes de México,* nos. 64-65.

Baus Czitrom, Carolyn
1978 *Figurillas Sólidas de Estilo Colima: una Tipología.* Colección Científica, no. 66. Mexico: Instituto Nacional Antropología e Historia, Departamento de Investigaciones Históricas.

Bell, Betty
1971 "Archaeology of Nayarit, Jalisco, and Colima." *Archaeology of Northern Mesoamerica,* Part 2. Edited by Gordon F. Ekholm and Ignacio Bernal, 694-753. Handbook of Middle American Indians, vol. 2. Austin: University of Texas Press.

Bernal, Ignacio
1969 *The Olmec World.* Berkeley: University of California Press.

Furst, Jill Leslie, and Peter T. Furst
1979 *Pre-Columbian Art of Mexico.* New York: Abbeville Press.

Furst, Peter T.
1965 "West Mexican Tomb Sculpture as Evidence for Shamanism in Prehispanic Mesoamerica." *Antropologica* 15: 26-80.
1978 *The Ninth Level: Funerary Art from Ancient Mesoamerica.* Iowa City: University of Iowa Museum of Art.

Gallagher, Jacki
1983 *Companions of the Dead: Ceramic Tomb Sculpture from Ancient West Mexico.* Los Angeles: Museum of Cultural History, University of California.

Kan, Michael, Clement W. Meighan, and H.B. Nicholson
1970 *Sculpture of Ancient West Mexico: Nayarit, Jalisco, Colima: The Proctor Stafford Collection:* Los Angeles: Los Angeles County Museum of Art.
1989 *Sculpture of Ancient West Mexico: Nayarit, Jalisco, Colima.* Albuquerque: University of New Mexico Press.

Kelly, Isabel
1945 *The Archaeology of the Autlán-Tuxcacuesco Area of Jalisco. Part I: The Autlán Zone.* Ibero-Americana, no. 26. Berkeley: University of California Press.
1949 *The Archaeology of the Autlán-Tuxcacuesco Area of Jalisco. Part II: The Tuxcacuesco-Zapotitlán Zone.* Ibero-Americana, no. 27. Berkeley: University of California Press.
1980 *Ceramic Sequence in Colima: Capacha, an Early Phase.* Anthropological Papers of the University of Arizona no. 37. Tucson: University of Arizona Press.
Letter, 1 January 1943, from Isabel Kelly to Robert H. Lowie, in Robert Harry Lowie Papers (C-B 927), The Bancroft Library, University of California, Berkeley.
Letter, 14 March 1943, from Isabel Kelly to Alfred Kroeber, in Alfred L. Kroeber Papers (C-B 925), The Bancroft Library, University of California, Berkeley.

Long, Stanley Vernon, and R.E. Taylor
1966a "Chronology of a West Mexican Shaft Tomb." *Nature* 212, no. 5062: 651-52.
1966b "Suggested Revision for West Mexican Archaeological Sequences." *Science* 154, no. 3755: 1456-59.

Lumholtz, Carl
1902 *Unknown Mexico,* 2 vols. New York: Charles Scribner's Sons.

Marks, Sheldon
1968 *The Jules Berman Kahlúa Collection of Mexican Pre-Columbian Art.* Los Angeles: N.P.

Meighan, Clement W.
1972 *Archaeology of the Morett Site, Colima.* University of California Publications in Anthropology, vol. 7, Berkeley: University of California Press.
1974. "Prehistory of West Mexico." *Science* 184, no. 4143: 1254-61.

Messmacher, Miguel
1966 *Colima.* Colección de Libros de Arte, no. 1. Mexico: Instituto Nacional de Antropología e Historia.

Meyer, Carl
1977 *The Plundered Past: The Story of Illegal International Traffic in Works of Art.* New York: Atheneum.

Nicholson, H.B., and Alana Cordy-Collins
1979 *Pre-Columbian Art from the Land Collection.* San Francisco: California Academy of Sciences and L. K. Land.

Sauer, Carl
1948 *Colima of New Spain in the Sixteenth Century.* Ibero-Americana, no. 29. Berkeley: University of California Press.

von Winning, Hasso
1974 *The Shaft Tomb Figures of West Mexico.* Southwest Museum Papers, no. 24. Los Angeles: Southwest Museum.

Illustrations

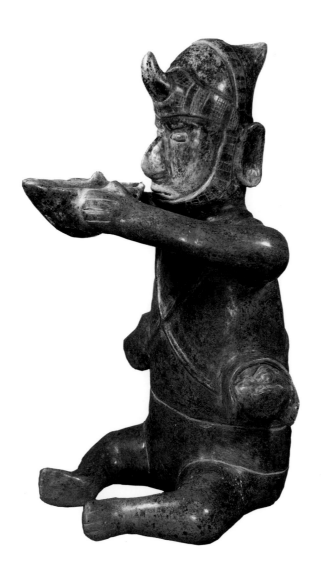

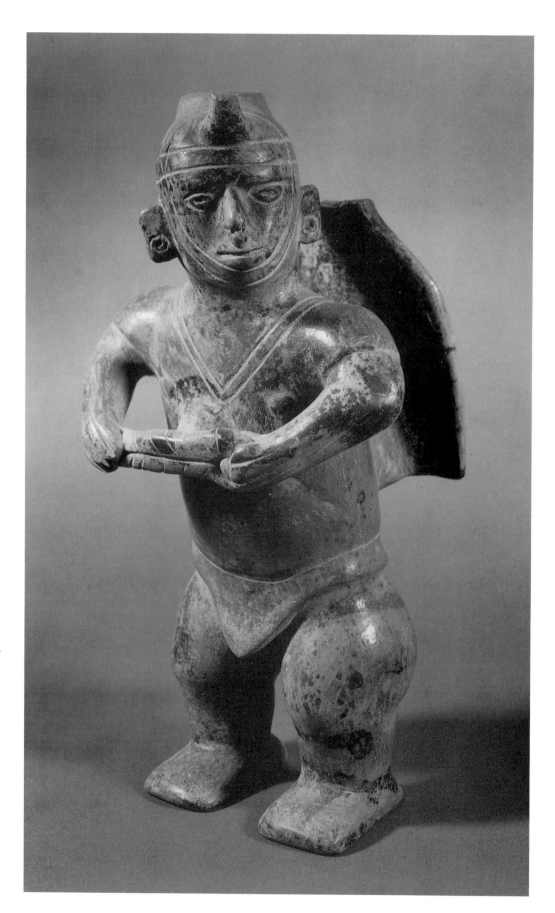

1.

Warrior with Sling and Back Shield

This horned figure was found near the town of Pihuamo, in the adjoining state of Jalisco. Peter Furst believes slings may represent spiritual "soul-catchers." Red-on-buff, incised. H. 38 cm., W. 20 cm.

2.

"Teco"

A featureless,
conehead figurine
sometimes referred
to by locals as a
"Teco."

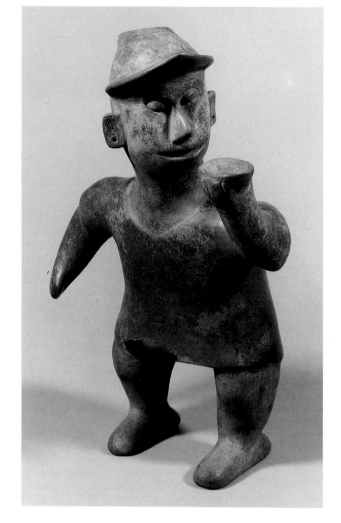

3 .

Figure Holding Oval-shaped Vessel

This figure is wearing a distinctive hat and cream-colored tunic on burnished red. There is a large firing cloud at base of the tunic. According to Dr. Isabel Kelly, large hollow figures are more difficult to classify than solid figurines. Height 32.1 cm., width 21.6 cm.

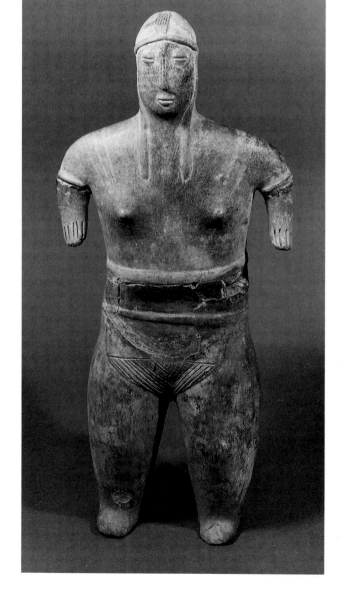

#4.

Large Standing Woman (Right)

This tomb figure features braided hair and short, fin-like arms. Previously published by Miguel Messmacher (1966: 61), the figure has extensive repair along the waist. Approximate height 61 cm.

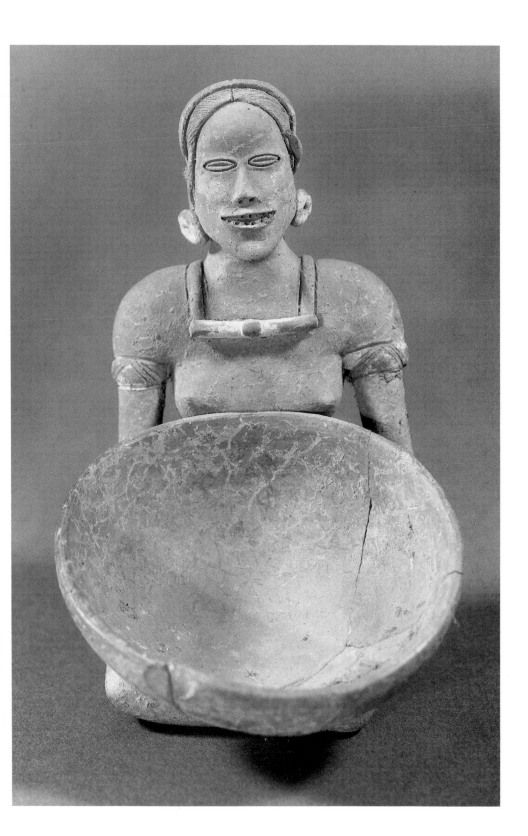

5.

Woman with Bowl

This lovely figure was reportedly found in Autlán, in Southern Jalisco. Note the life-like modeling and intricate, incised designs on hair and skirt. White decorations on un-slipped buff.
H. 15 cm., L. 11 cm., Bowl diameter 10 cm.

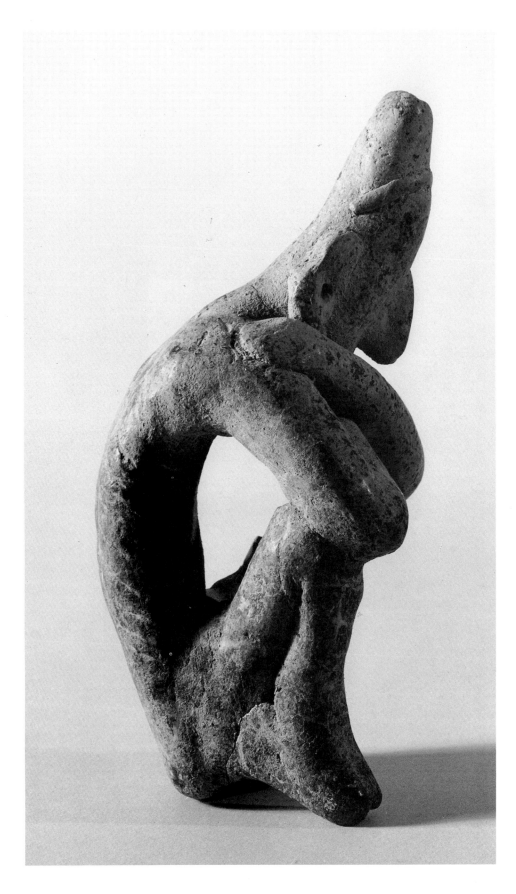

6.

Emaciated Old Man

Deformities seemed to
have fascinated the an-
cient potters of Colima.
Deformed spines, boils,
scarifications, bloated
body parts are all
protrayed with an un-
mistakeable solemnity
of life. This particular
figurine shows a male
with an exposed ribcage
and spine. Similiar to
the "Teco" style.
Height 19 cm.

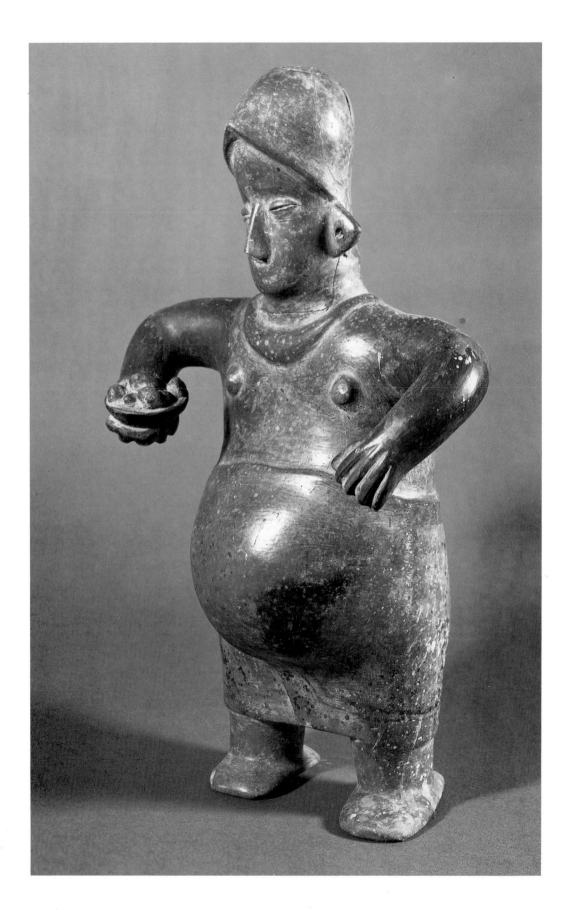

7.

Pregnant Woman Holding Bowl of Maize

Burnished red with large firing cloud on a wraparound skirt. Repair on neck.
H. 43.2 cm.,
W. 29.2 cm.,
D. 17.8 cm.

8.

"La Bruja" or witch.

This crude, hand-molded
figurine is similar to the
"Capacha" figurines classified
by Dr. Isabel Kelly and may
belong to the oldest period in
Colima. Baked, unfired clay.
Circa 1500 B.C.
Height 22.9 cm., width 5.1 cm.

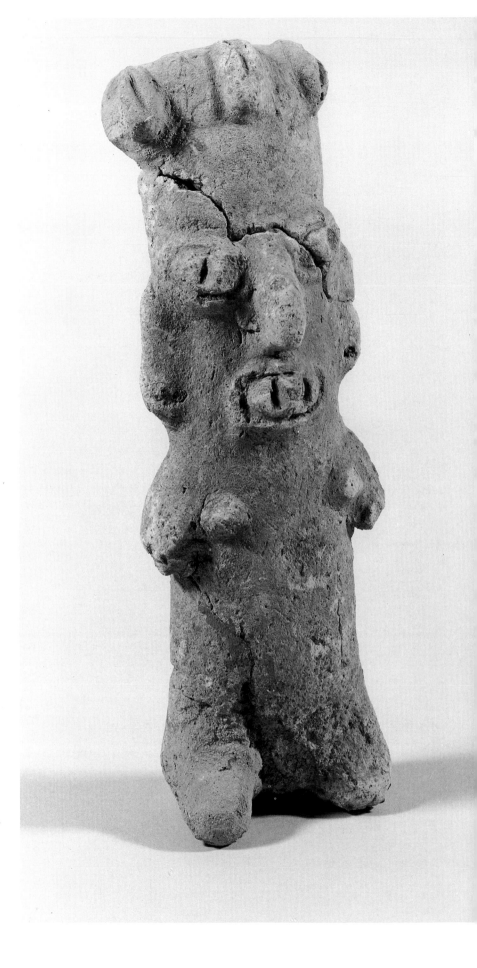

9.

Tecoman Figurine

Female figurine, hand-molded clay. Armlets, knee decoration.
H. 9.5 cm., W. 7 cm.

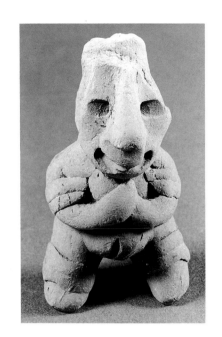

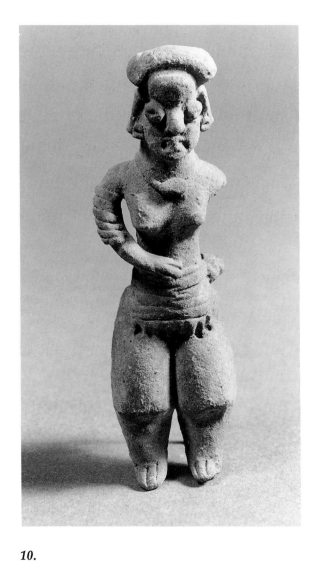

10.

"Crude" Figurine

Similiar in style to Baus Czitrom's "Tipo I, Figurillas Cintura de Avispa." Height 11 cm.

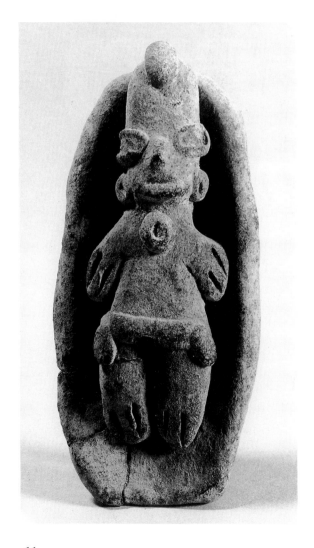

11.

"El Muerto"

Small figurine with goggle eyes, traces of red paint, earrings, circle bead necklace. H. 14 cm.

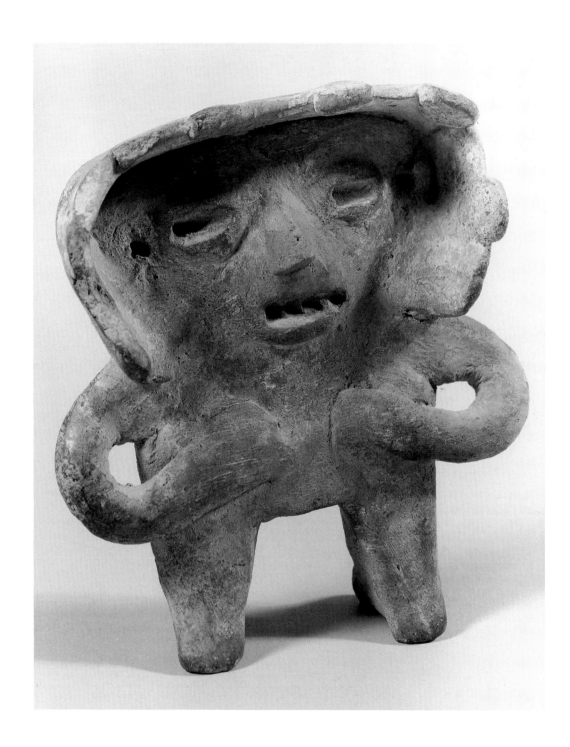

12.

Figurine

Colima art styles generally fall into a dozen or so categories. This hand-molded figurine, with blinder-type bonnet, is an exception. Unslipped buff. Height 12 cm.

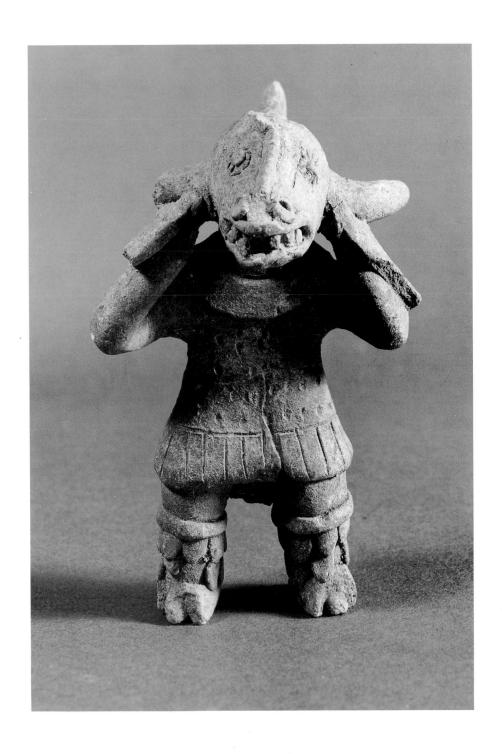

13.

Warrior With Fish-head

Anthropomorphic figurines, such as dogs wearing human masks, are commonplace in Colima and may represent beliefs and rituals of the people who inhabited this region fifteen hundred years ago. The depicted fish-headed figure may represent a warrior in costume, or human transformed into a fish. It is similar to figure # 60 in Jacki Gallagher's *Companions of the Dead* (1983: 60)
Height 12 cm.

14.

Dwarf

Hunchbacks and dwarfs were a popular theme in the shaft-chamber tomb culture, and the abundance of dwarf and hunchback figurines found in the shaft tombs of Colima underscores their special status. Peter Furst believes dwarfs in ancient Mesoamerica may have been shamans or sorcerers, possessing occult powers and able to communicate with the netherworld. This deformed "hunchback" may be a variant of a Coahuayana style. Approximate height 20 cm.

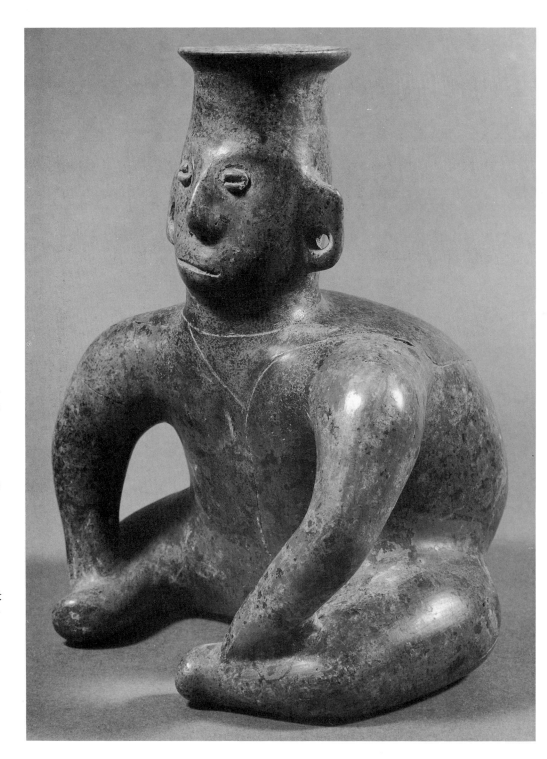

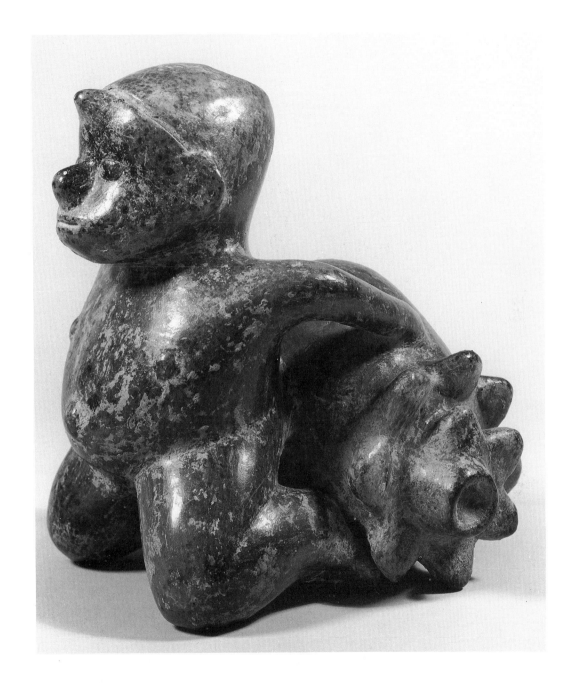

15.

Dwarf Figure

Like most seaside dwellers, the ancient people of Colima were
preoccupied with the sea, which provided mythology and subsis-
tance. This deformed figure is on his knees and pulling a conch
shell. Height 18 cm.

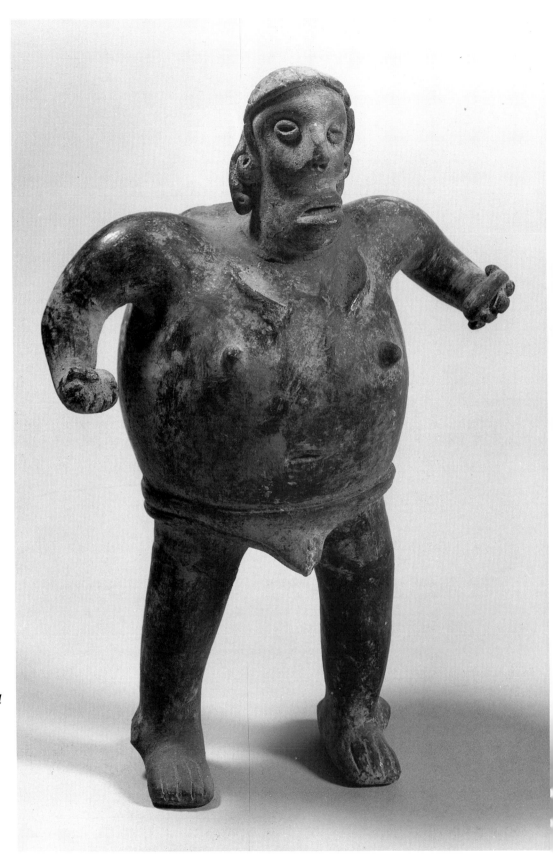

16.

Warrior with Bloated Stomach

Holding rectangular objects (weapons or Maize) in both hands. Scoop loin cloth.
H. 20.3 cm., W. 14 cm., D. 7.6 cm.

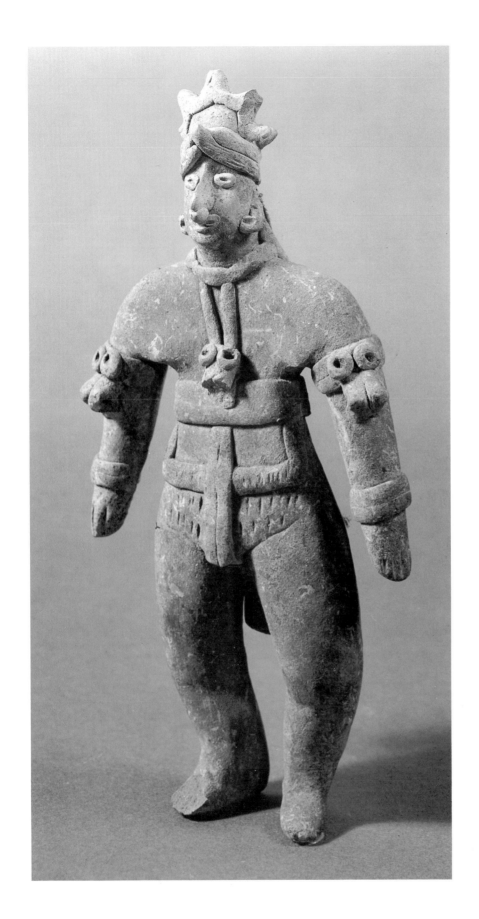

17.

"Gingerbread Rey"

A classic, Tuxcacuesco-Ortices phase figurine from Colima (see Kelly 1949:118). The figurine's distinctive headgear — with bands and coils encircling the forehead — may indicate civil or religious rank. Height 29 cm.

18.

Standing Woman

White decoration
on burnished red.
The woman is
wearing a
wraparound skirt,
turban, earrings,
and a necklace.
H. 33 cm.,
W. 20.3 cm.,
D. 7.6 cm.

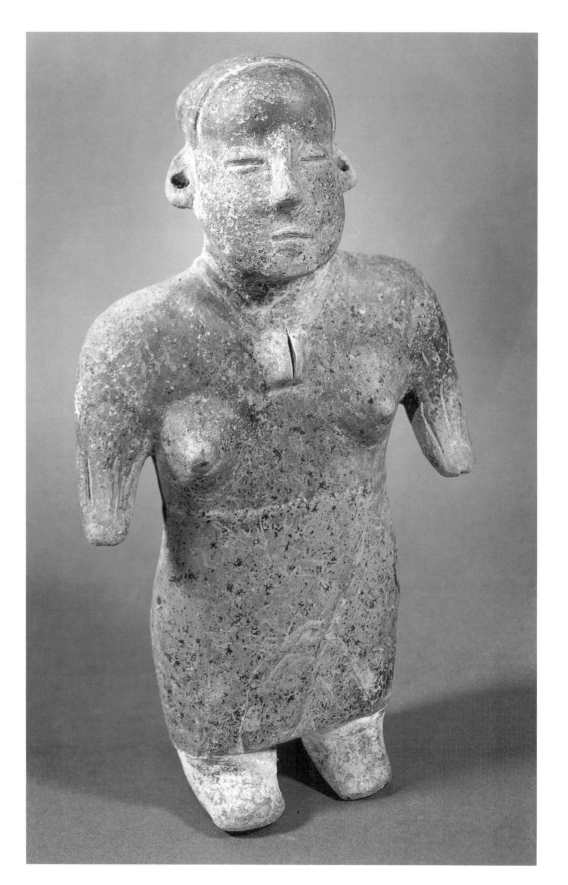

The Ancient Art of Colima, Mexico

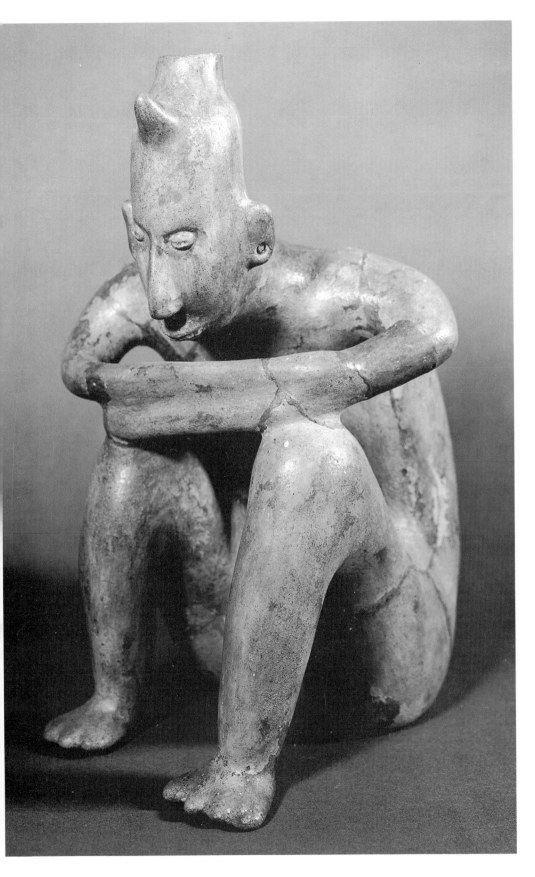

19.

Web-Footed Shaman

Peter Furst believes that most of the creatures depicted in the funerary art of western Mexico can be interpreted through Huichol symbolism (1978: 27). Since horns are shamanic emblems among the Huichol and signify magical power, Furst has suggested that many of the warrior figures are, in fact, shamans. Burnished orange, with repair. Height 38 cm.

20.

"Tecoman"

Exagerated nose, elongated forehead, and coffee-bean eyes.
Similar to Baus Czitrom's "Tipo XVIIId: Figurillas Tablilla sin Cuello" (1978: 100). Unslipped buff.
Height 16.5 cm.

21.

Two Figurines

These figures, with arms crossed in a characteristic Colima pose, were reportedly found in a tomb near Ixtlahuacán, near the Rio Salado.
Approximate height 11 cm.

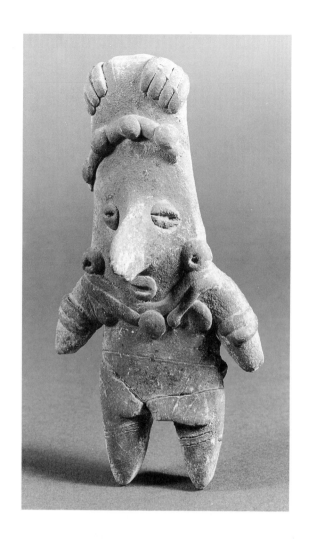

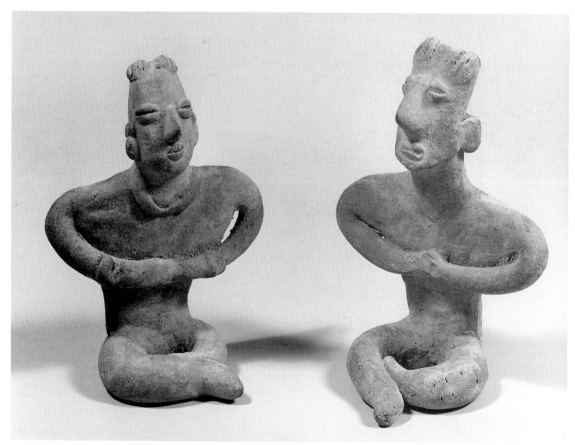

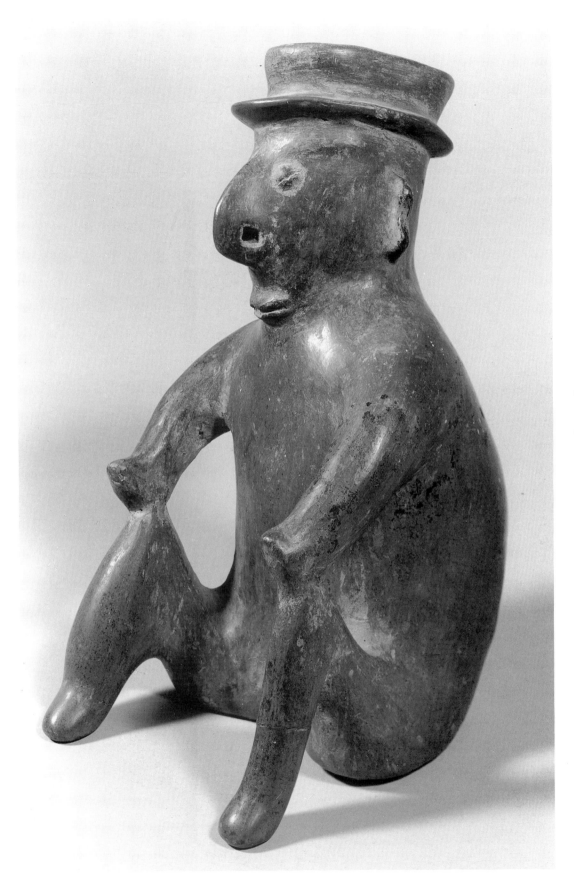

22.

Seated Figure with Hands on Knees

Dark red burnish.
Hooked nose,
pierced nostrils,
coffee-bean eyes.
Height 25.4 cm.
Width 13.3 cm.

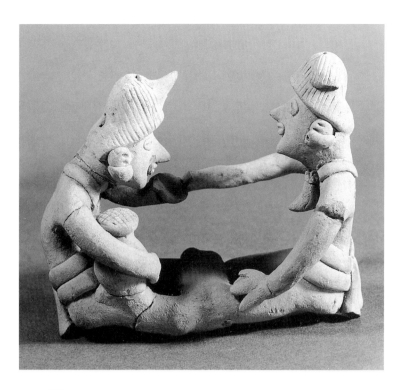

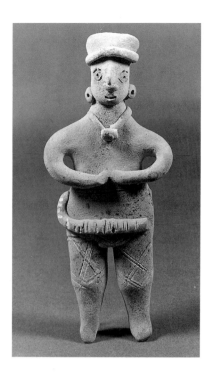

23.

Whistles

Unslipped buff. Tuxcacuesco-Ortices type.
Height 9.5 cm.

24.

Autlán Figurine

White paint on solid unslipped
buff with "Diamond-eyes."
Approximate height 15 cm.

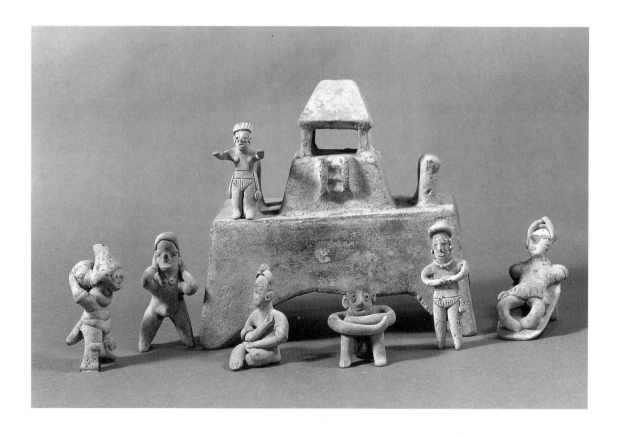

25. *Temple Figures*

Seven figurines, randomly grouped, illustrating a wide range of activities.
Doña María Ahumada de Gómez Collection. Temple height 19 cm.

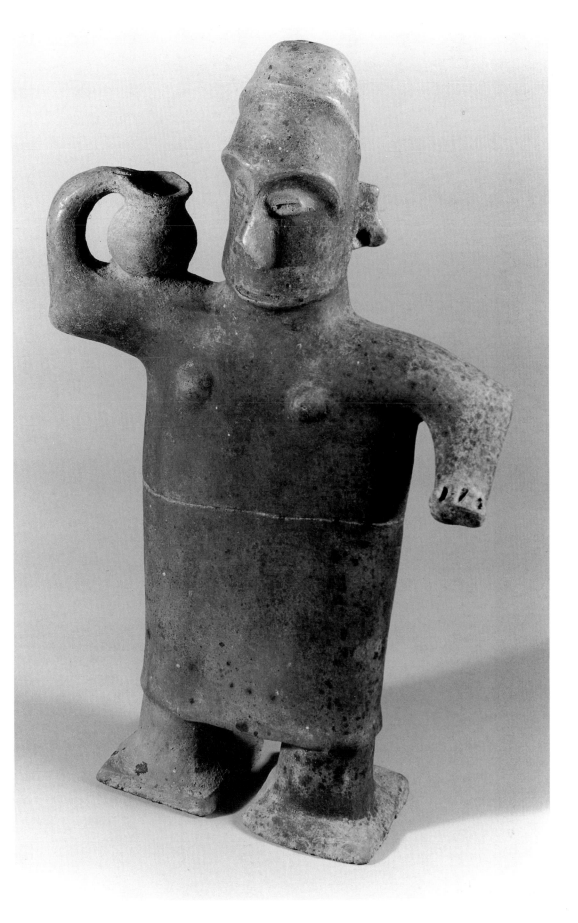

26.

Woman with Bowl on shoulder

Square feet, simple mantle. This sculpture, from the Museo de las Culturas de Occidente, appeared as the cover illustration in Miguel Messmacher's book *Colima* (1966), published by the Instituto Nacional de Antropología e Historia.

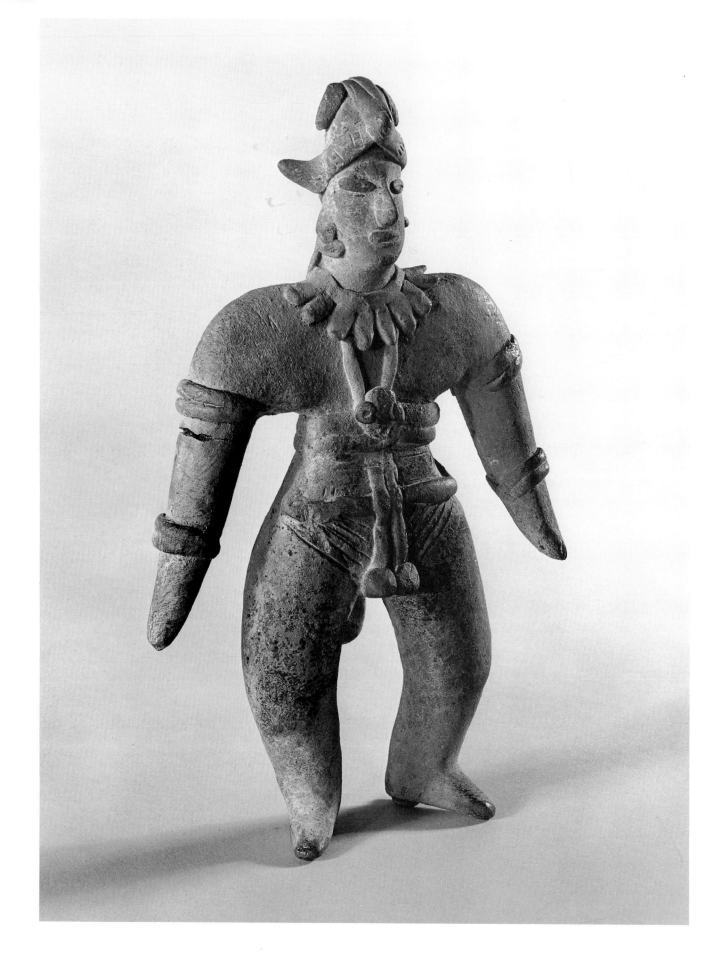

27.

"Gingerbread"

"Tuxcacuesco-Ortices" type. The name Tuxcacuesco is reportedly derived from a sacred stone above which a bird or *tustle* is placed (Kelly 1949:12). Approximate height 27 cm.

28.

"Tabliado" with Child.

Height 26.5 cm.

29.

Two "Gingerbread" figurines

"Tuxcacuesco-Ortices" type. Approximate height 14.6 cm.

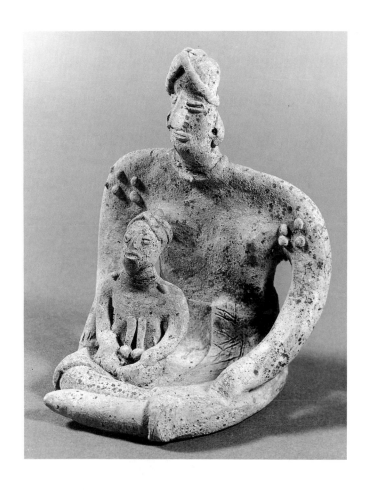

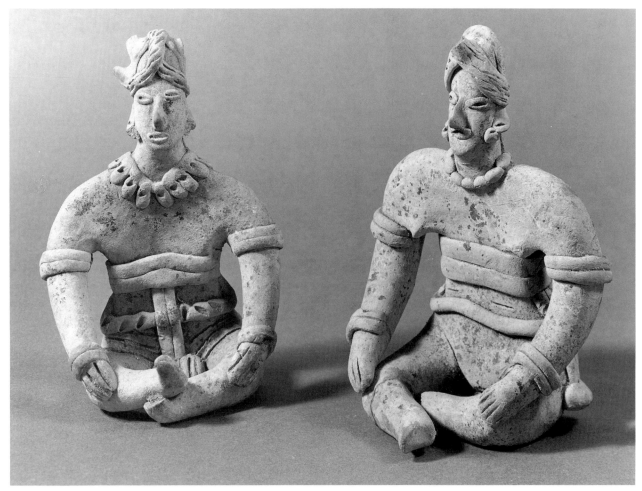

30.

*Decapitated
Figure*

Armless, headless
figurine with bul-
bous knees.
Double pendant.
Incised skirt.
Height 8.3 cm.

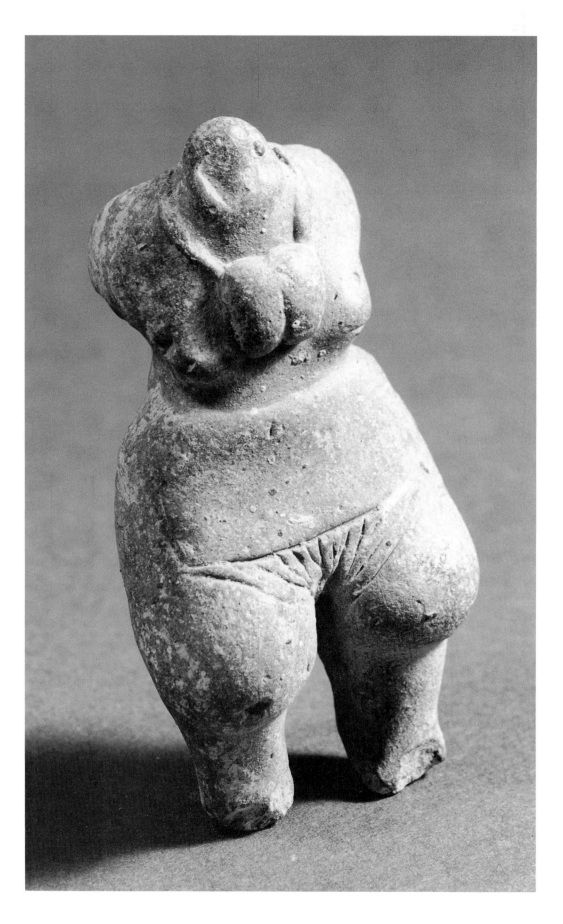

31.

"Teco"

An abstract depiction of the Colima warrior. Burnished brown. Highly polished patina. Height 19 cm., width 7.6 cm.

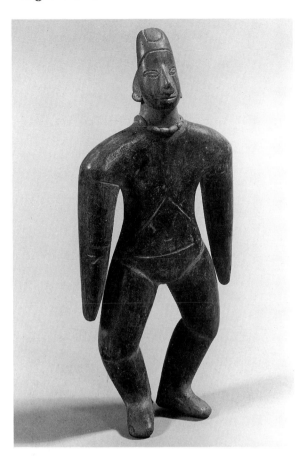

32.

Figure Grinding "Maize"

Carolyn Baus Czitrom designates this figurine with minimal features as "Teco de ojo inciso." This style is very common in Armería.

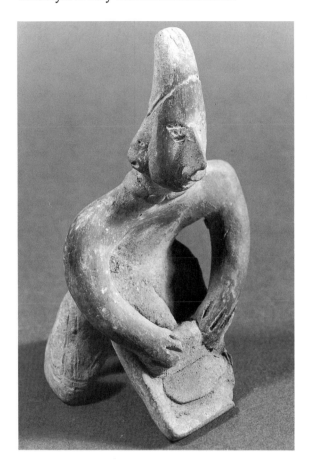

33.

Three Figures

Height (Left to right): 5.1 cm., 6.3 cm., 8.3 cm.

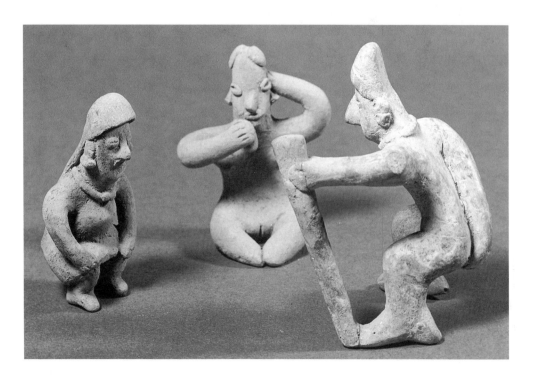

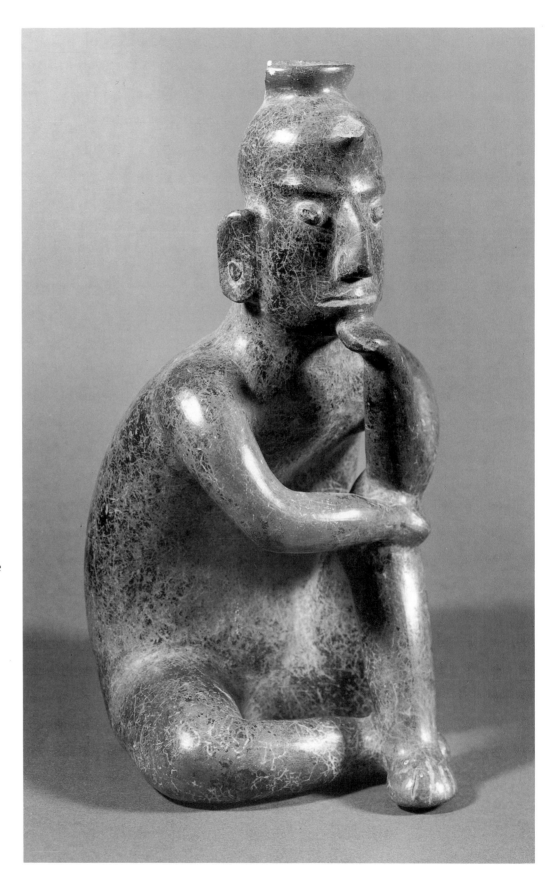

34.

The "Thinker"

The highly-polished surface of this piece is covered with extensive rootmarks. Approximate height 35.6 cm.

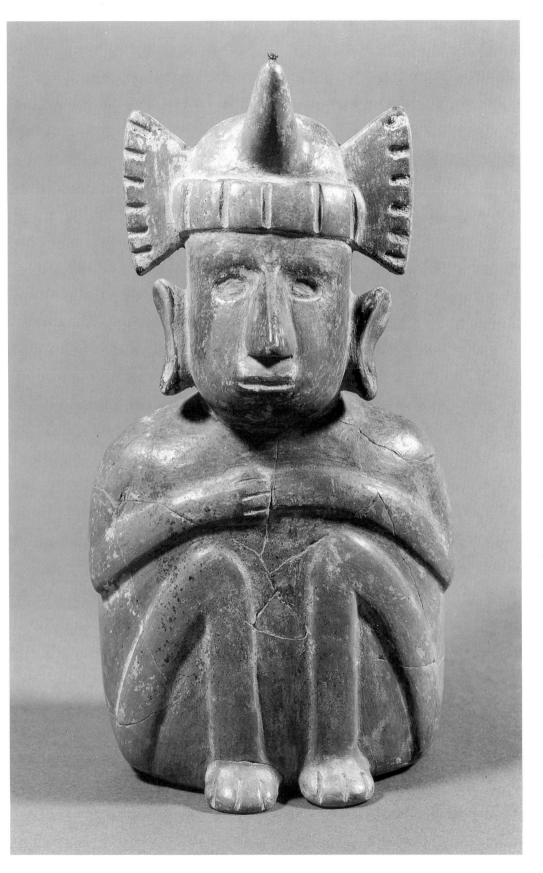

35.

Horned Warrior

This burnished orange vessel is an odd subtype with sunken eye sockets and depressions in the ears that may have once contained shell inlays. Unseen in this photoraph is a spout-like oriface. The piece was smashed and repaired.
Height 26.7 cm.
Width 16.5 cm.

36.

Kneeling Water-Carrier

This exquisite, dark-red burnished piece found its way to the local Museum in Colima, maintained by Doña Mariá Ahumada de Gómez. It was originally published in *El Deporte Prehispanico* by Revista Artes de Mexico, 1960, and was also published by Miguel Messmacher (1966:69).

Approximate height 29 cm.

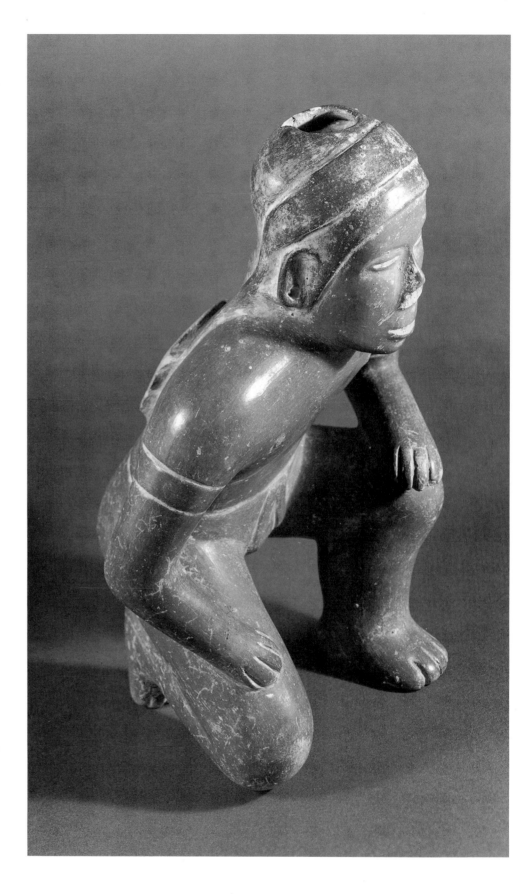

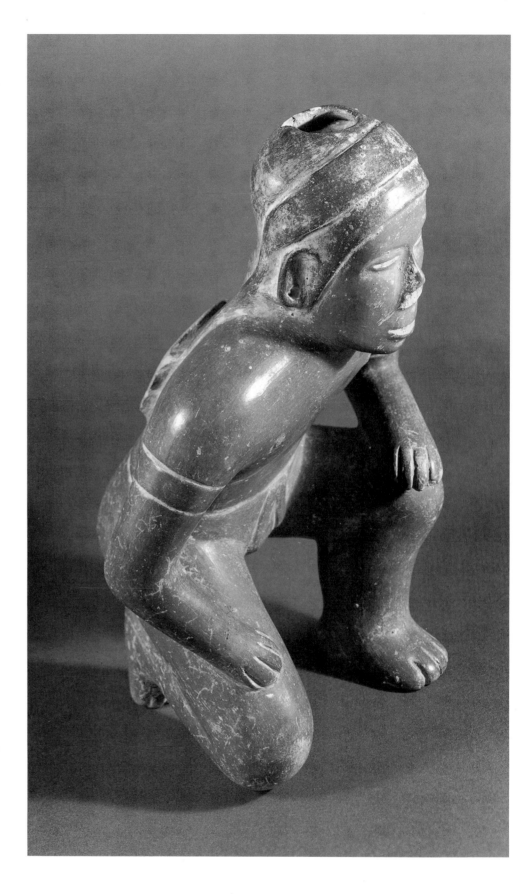

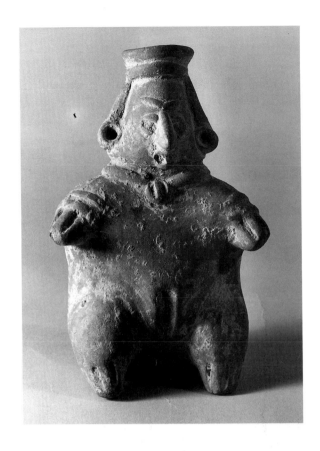

37.

Coahuayana Valley-type Figurine

This nude "fat lady" displays the distinctive features of effigy vessels from the Coahuayana Valley. Note arm pellets, earspools, necklace, and black painted designs on legs. See Von Winning 1974:figs 47-48, and the Stafford Collection, **Sculpture of Ancient West Mexico** 1989: 130 a-b.
Approximate height 19 cm.

38.

Group of Four Figurines

Reportedly from a ranch west of Río Coahuayana. Circa 200 B.C.
Height from left to right:
14.6 cm., 21.6 cm., 10.2 cm., 16.5 cm.

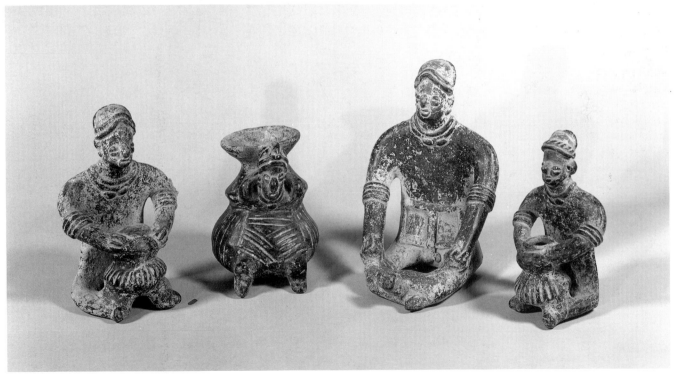

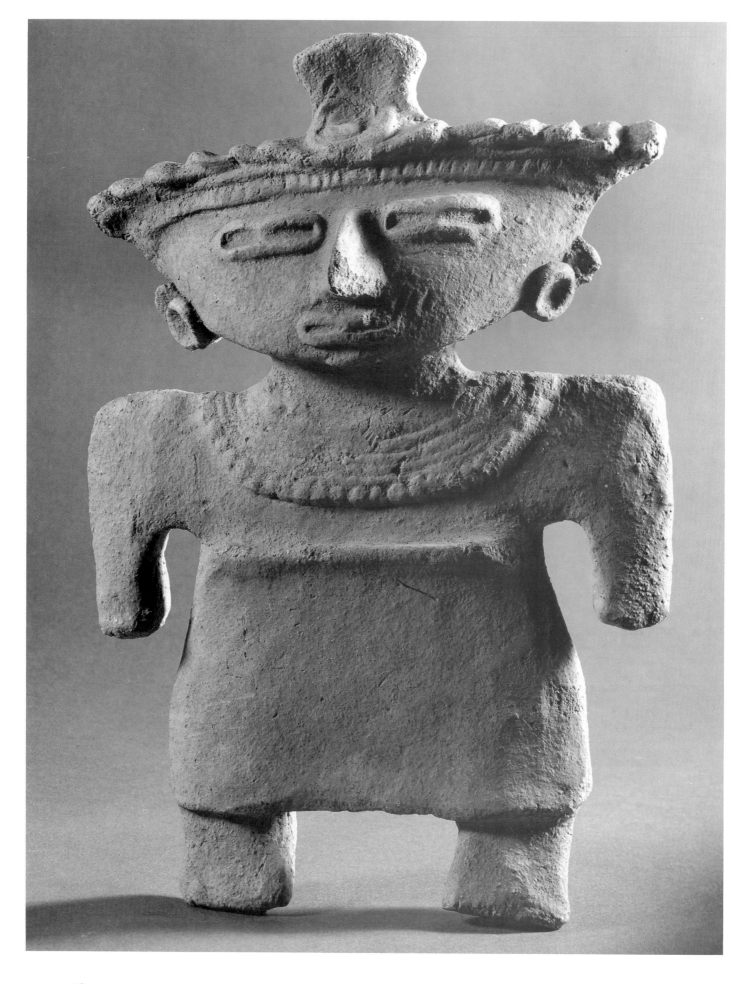

58

FACING PAGE

39.

"Cabesa Ancha"

Triangular faced figurine with rectangular eyes, slab headdress and layered necklace. From Tecoman. Height 26 cm., width 19.7 cm.

40.

Pinhead

Large female "teco" with incised features and tadpole-like arms. Height 38 cm.

41.

Group of three figures

From Doña María Ahumada de Gómez Collection. Heights: 7 cm., 12 cm., 8 cm.

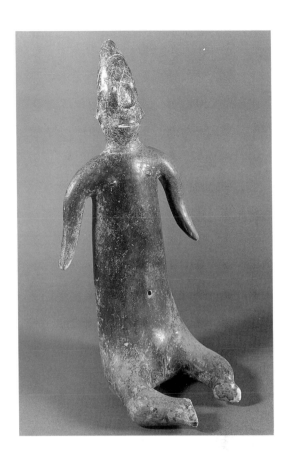

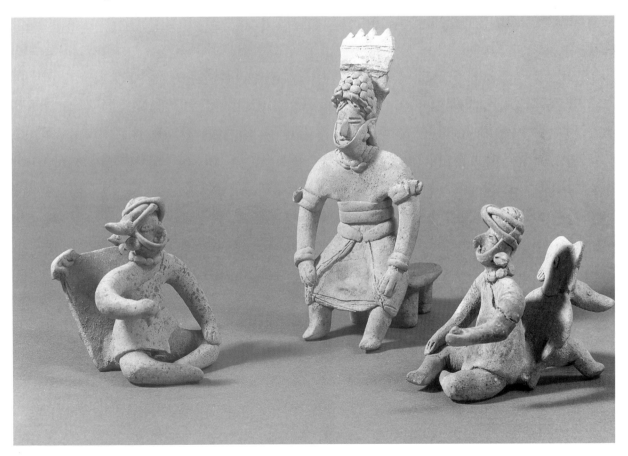

42.

"Tabliado"

This style is often
found in the Tecoman
and coastal area.
It blends the typical
coffee-bean eyes and
facial features with a
plate-flat body and
string arms.
Height 26 cm.

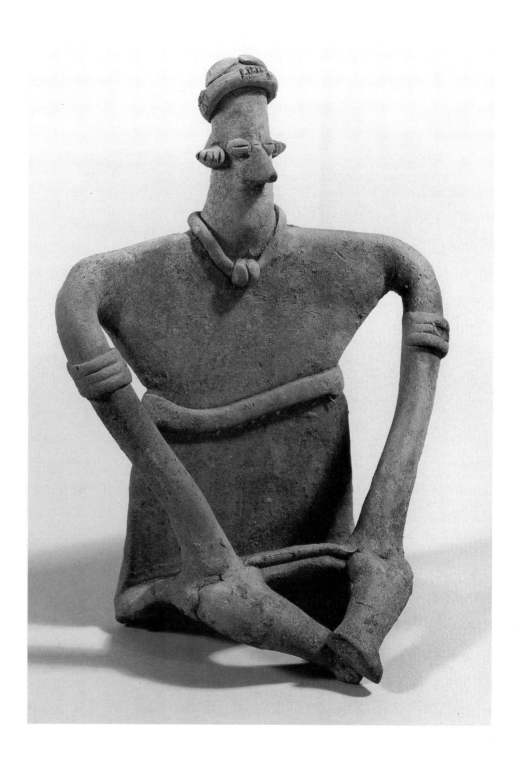

The Ancient Art of Colima, Mexico

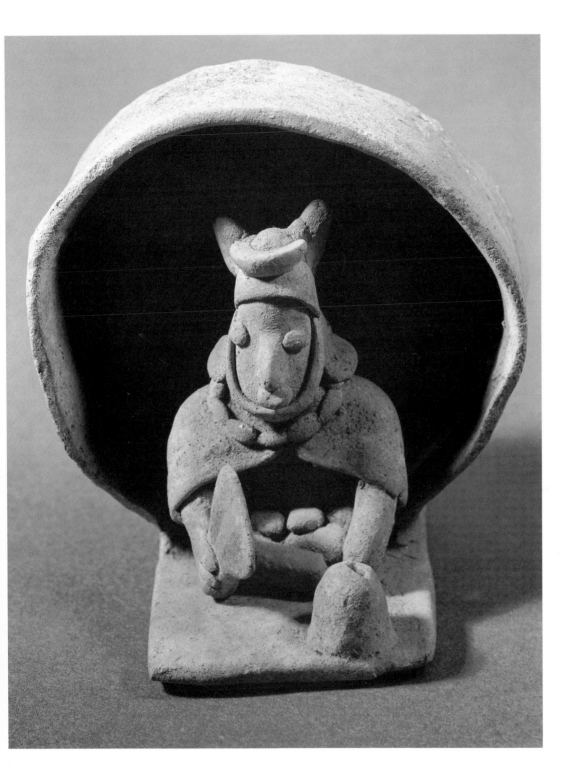

43.

"Shaman"

Unslipped buff figurine with crescent moon turban sitting beneath an "umbrella." Figurine may depict a shaman fanning an incense urn. Height 9.5 cm.

44.

Single leaf, Gold Necklace

The Spanish were attracted to the state of Colima by the reports of great wealth and precious metals, and Colima was thought to be the source of the Aztec gold. Although the state is incredibly rich in mineral resources, gold and silver artifacts are rare, and most probably date from later periods. This single leaf of a golden necklace, is allegedly from El Chanal, along the Rio de Colima, four miles upstream from Colima. El Chanal is unique and is the only site even resembling a ceremonial center. There are remnants of a small pyramid and perhaps a ball court. But when moneros digging in El Chanal reported finding corpses covered with "sheets of flattened gold," the cemetary was ripped apart and quickly looted.
Approximate length 7 cm. Width 9.7 cm.

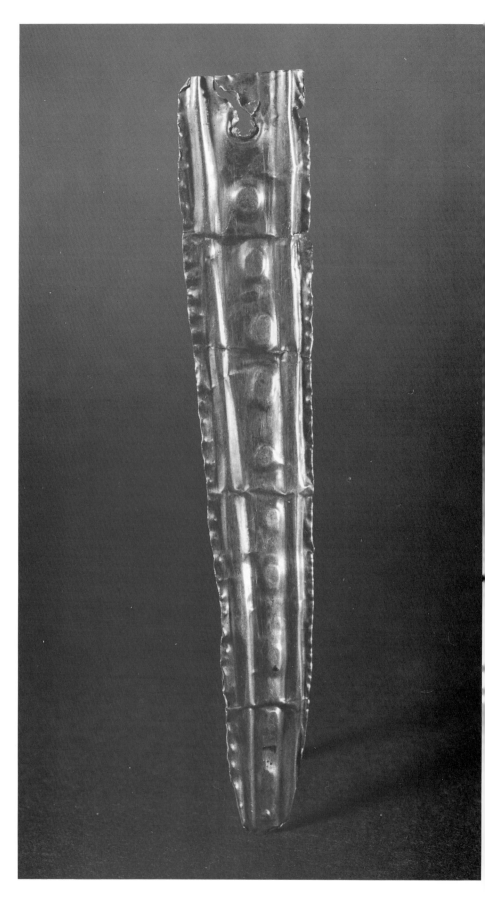

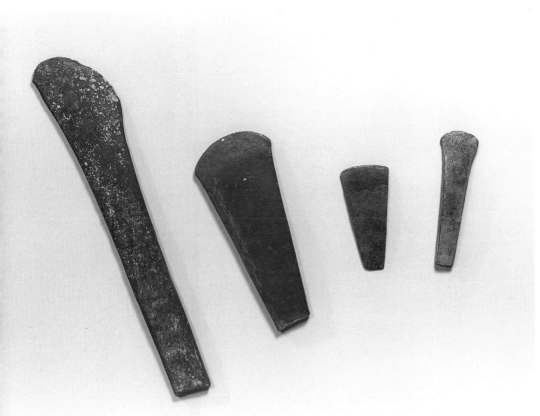

45.

Metal Objects

Metal objects arrived relatively late in Mesoamerica, and may date from the years immediately preceding the Conquest. Dr. Isabel Kelly reports that the quantity of copper artifacts found in Colima is so small that they may have been acquired through trade (1949: 151). Others have suggested they may have been introduced from South or Central America, where it was known earlier.
Axe Lengths: 25 cm., 13 cm., 7 cm., 9 cm.

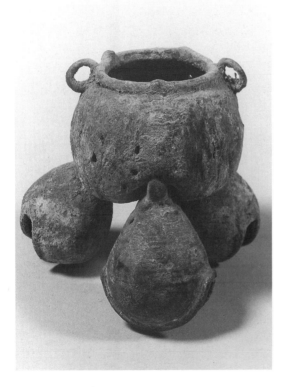

46.

Copper Bell

Spherical copper bells, sometimes containing rattles, are the most common of all metal objects found in Colima.
Height 6 cm.
Orifice 2.8 cm.

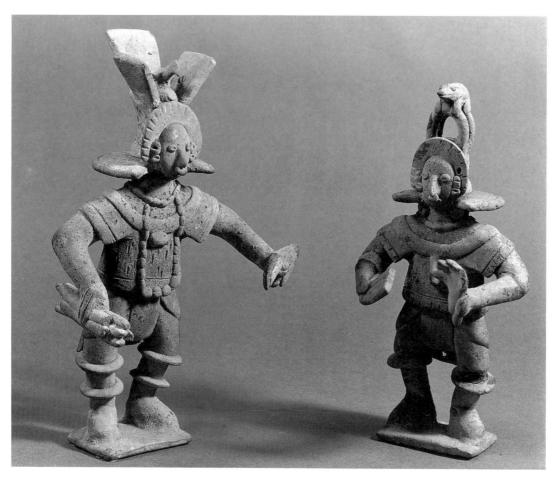

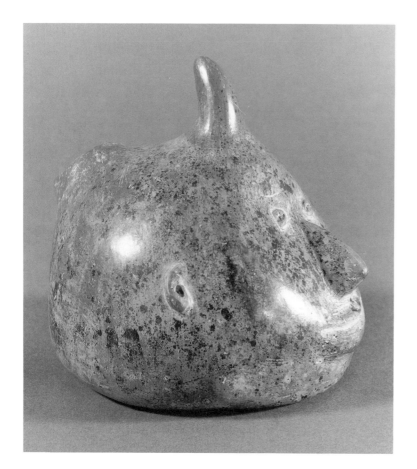

ABOVE:

47.

Two Warriors

Figurines in full regalia, including animal tokens on helmets.
Doña María Ahumada de Gómez Collection.
Heights 19.1 cm., 16.5 cm.

48.

Head Pot

Head pots are common in the Colima collections, and some believe they are evidence of contact with South America.
Height 12 cm.

FIGURE OPPOSITE: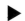

49.

Figurine From Armería

"Goggle" eyes, hair in ringlets.
Height 17.8 cm., width 12.7 cm.

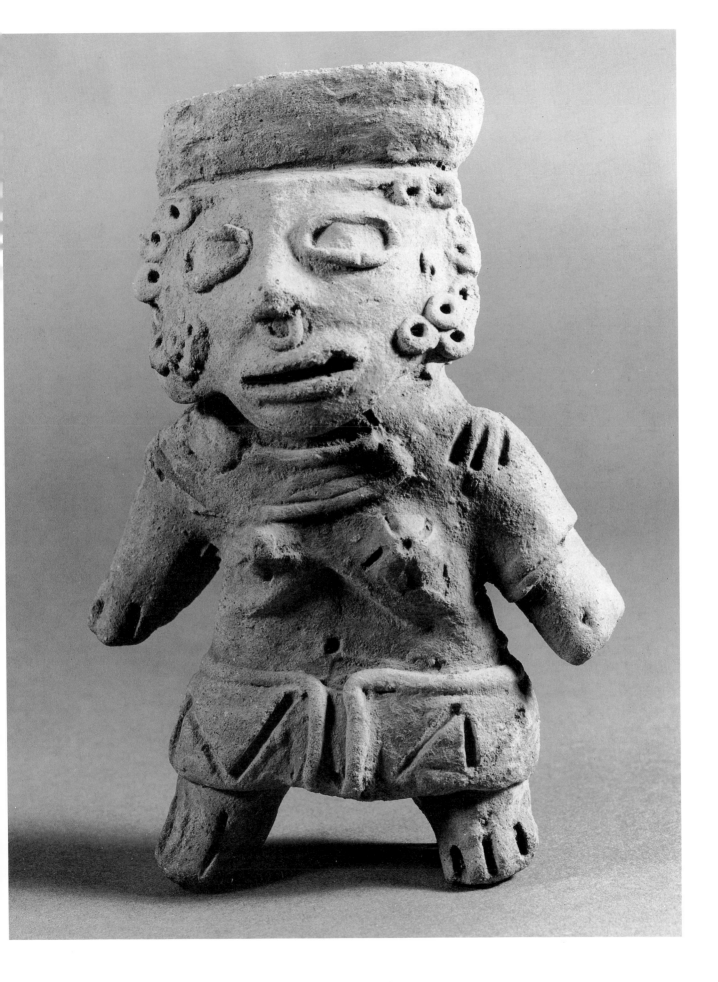

50.

Woman Figurine

This unslipped buff
figurine is very similar
to Carolyn Baus
Czitrom's "Tipo IIIa:
Figurillas Acinturadas"
(1978:76)
Height 14 cm.

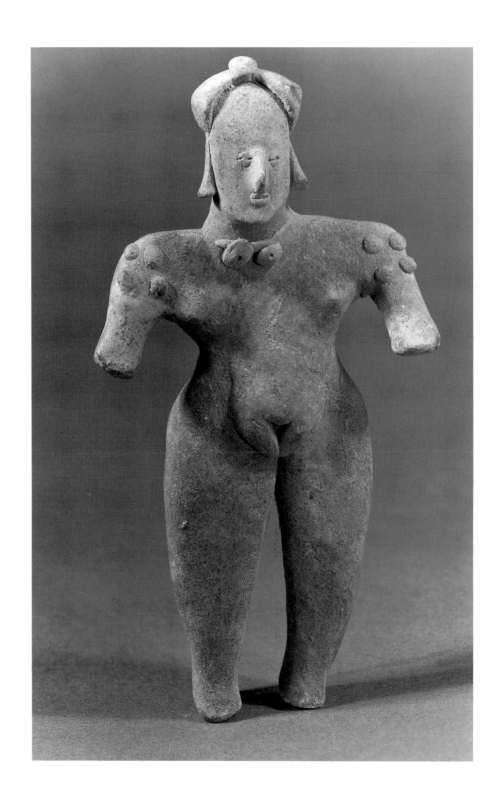

The Ancient Art of Colima, Mexico

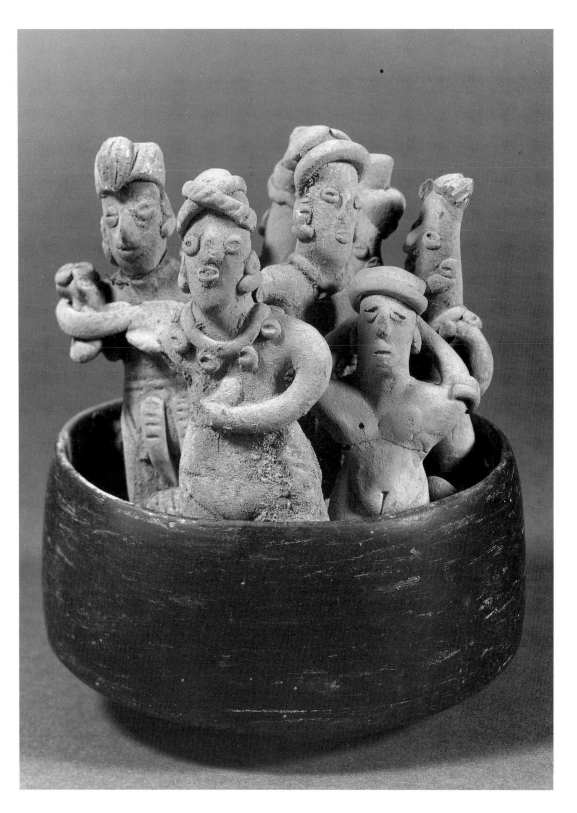

51.

"Gingerbread"
Figurines in Black
Bowl

Nine variously
attired figurines
standing in a
black bowl. The
figurines are
solid, unslipped
buff, and similar
to Kelly's "Tux-
cacuesco-Ortices"
type (see Kelly
1949:271).
Height 12 cm.

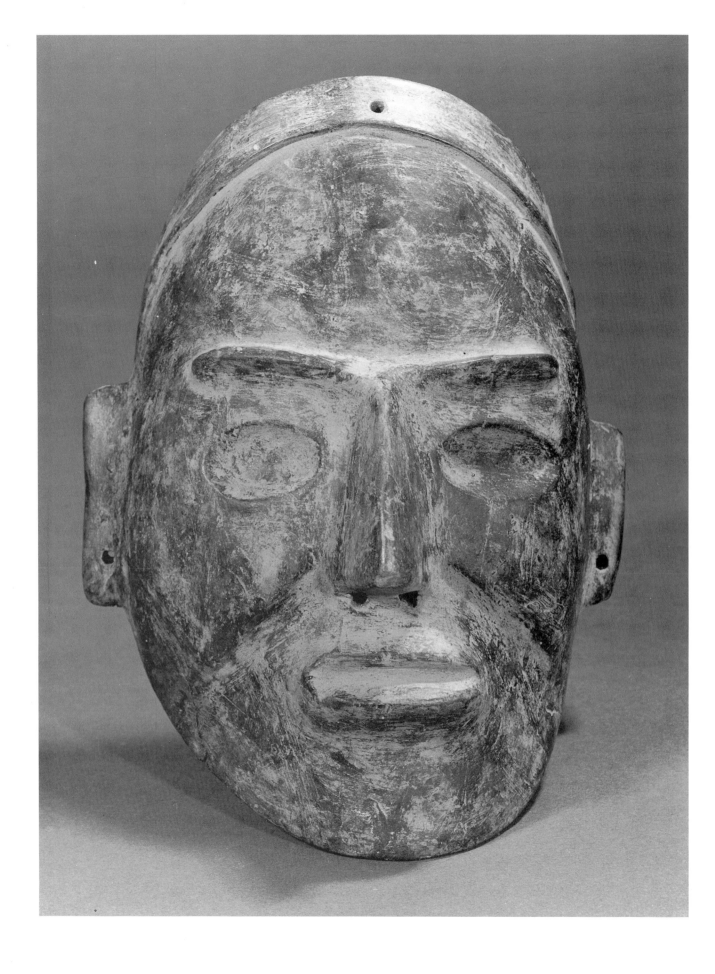

53.

Tomb Headrest

Holes on sides for tying head in place. Traces of white paint. Width 15.9 cm.

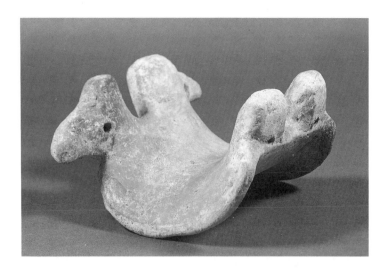

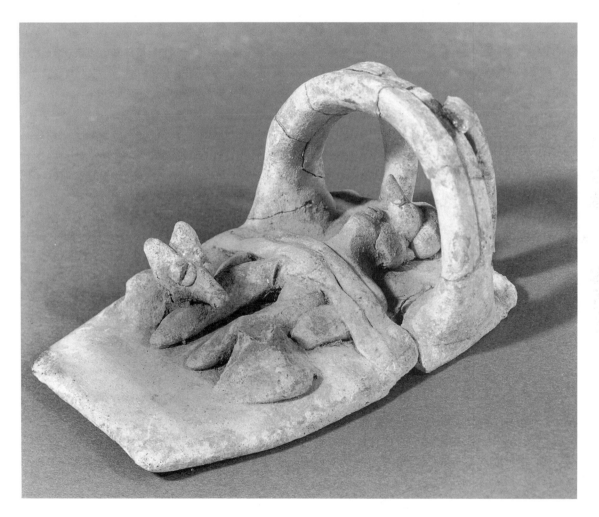

◀ *FIGURE LEFT*

52.

Black Portrait Mask

Unique to the Colima region, these black clay masks may have functioned as pectoral decoration or may have been placed over the faces of the deceased in the shaft tombs. Length 26 cm.

54.

"El Muerto"

This figure, accompanied by two dogs, is strapped to a pallet with protective loop over the head. This typical scene may depict the manner in which bodies were lowered into the shaft-tombs (Hasso von Winning 1972: 33-35). Length 12.1 cm.

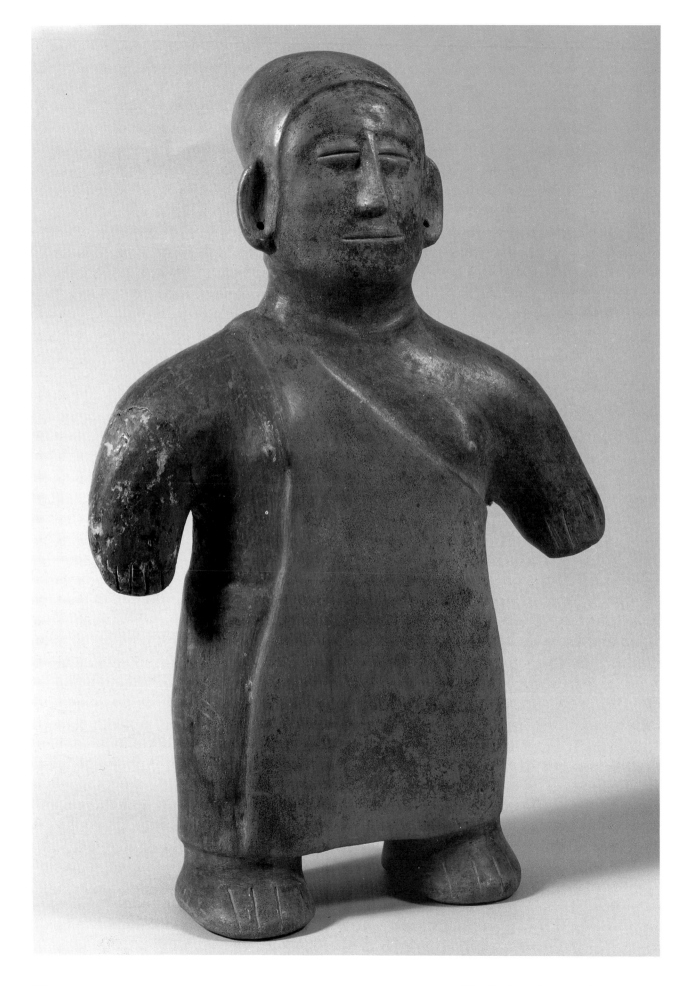

56

Three Clay Pipes

Left to Right: 8.9 cm., 12.7 cm., 15.2 cm.

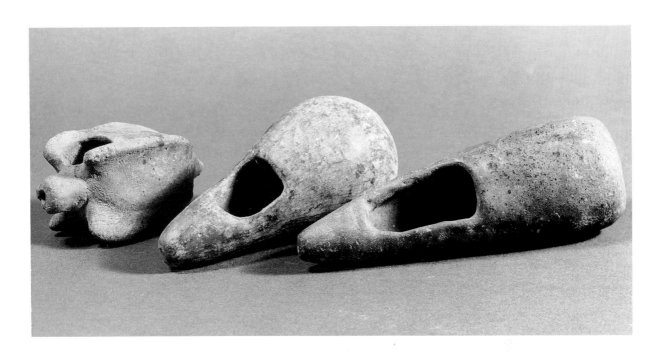

FIGURE LEFT

55.

Standing Figure

This large, burnished red figure features a tight-fitting skull-cap, pierced ears, and shoulder-strap costume. From the Doña María Ahumada de Gómez Collection. Height 45 cm.

57.

Three Figurines

Randomly arranged. Please note the figurine "smoking a pipe" through nostril.

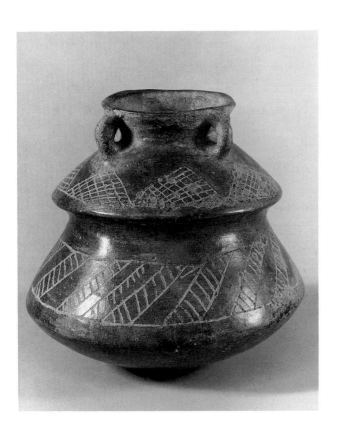

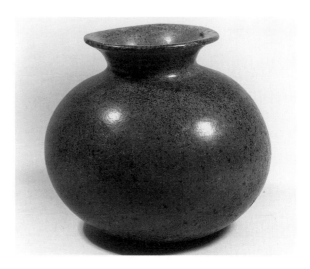

59.

Vessel

Globular vessel with burnished red slip.
Approximate height 20 cm.

58.

Brown-Black Bowl

Incised designs.
H. 22.9 cm., W. 22.9 cm., D. 11.4 cm.

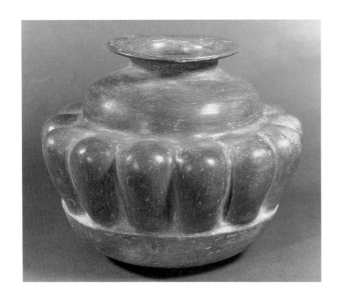

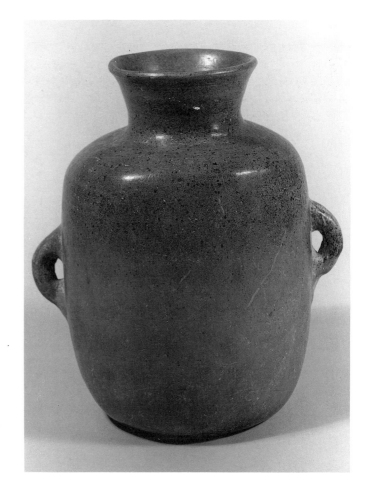

60.

Phytomorphic Vessel

Burnished red. Height 23 cm.

61.

Plain Bowl

Burnished red.
Height 22 cm., width 20.3 cm., orifice 10.2 cm.

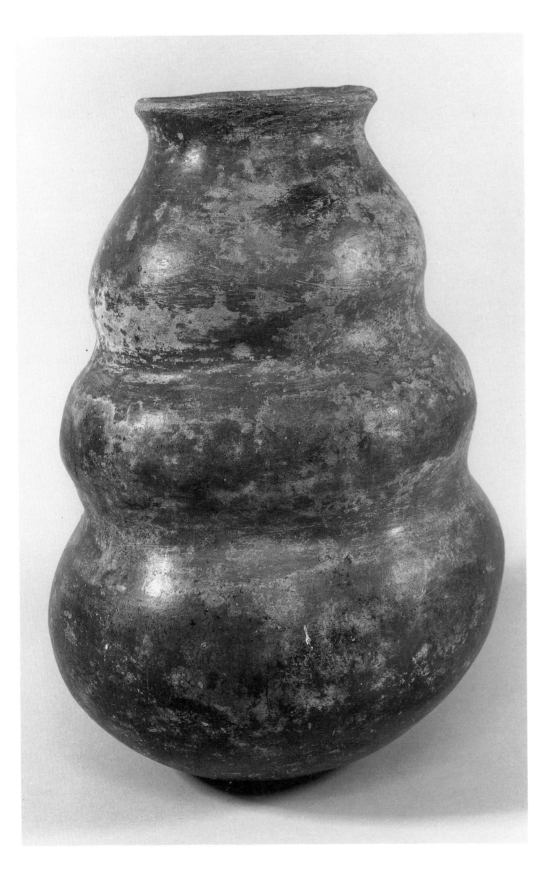

62.

Large Vessel

This tall, seemingly "uninteresting" vessel is similiar to the "bules" that Dr. Kelly found in Colima and may belong to the Capacha phase, designated by Dr. Kelly as the oldest period in Colima. The characteristic Capacha "sunburst" design is missing, however.

63.

Seated Warrior

This burnished, red-orange figure holding an oval-shaped bowl and criss-cross "trophy heads" was first published in Justino Fernandez's *Mexico's Prehispanic Sculpture* (n.d.: fig.1). Approximate height 46 cm.

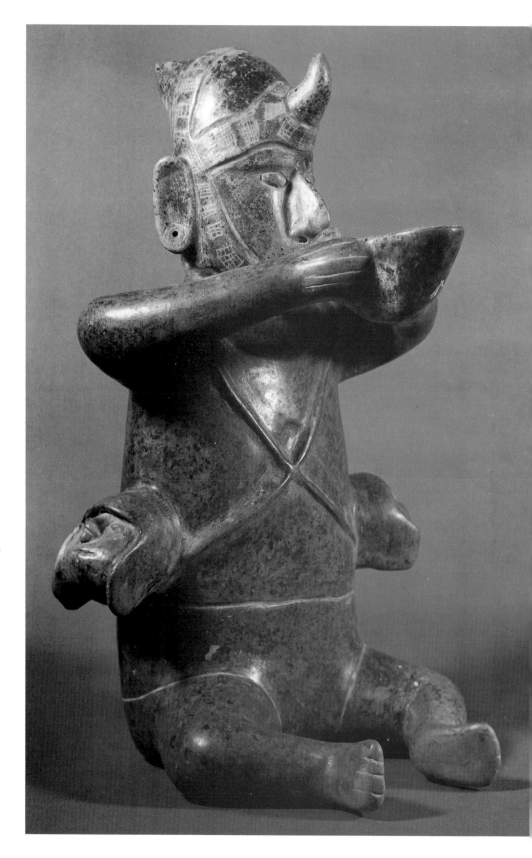

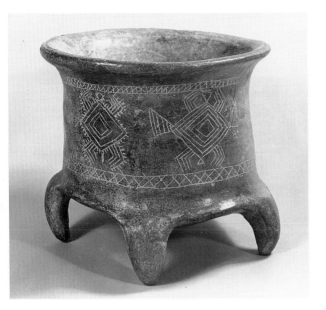

64.

Bowl

Burnished gray-brown bowl with an un-
usual four legs for support. Incised
designs depicting crabs. Height 12 cm.

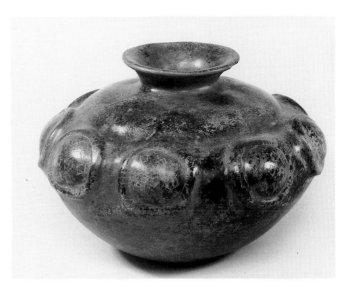

65.

Nine Turtles

Red, cream-brown pot with black inclusions.
Reportedly found in a cave near the town of
Pihuamo.
Height 20 cm., width 32 cm., orifice 51 cm.

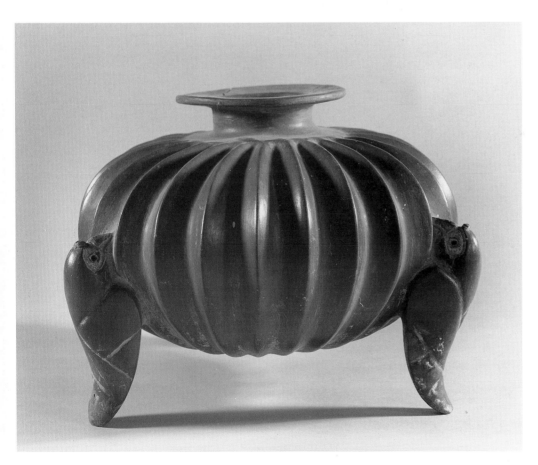

66.

*Tripod Vessel with
Parrot-shaped Feet*

Gadrooned vessel with
burnished red slip.
Height 25 cm.,
Diameter 35 cm.

67.

Fat Dog

Ceramic depictions of dogs in Colima pottery is legendary, and the Colima dog was one of the first Colima tomb pieces published (Batres 1888: plates 23,25). Colima dogs are depicted in almost every conceivable posture — barking, scratching, fighting, howling, or sleeping. The dogs are usually represented as plump, and some have suggested the dog was a culinary delicacy. Other scholars (Toscano 1946: 24) have suggested that certain animal figures represent the "companion spirit" of the deceased (see figure #54), and that the dogs represent emissaries of *Xolotl*, god of death. This might explain the depiction of the dog with human attributes, and why the animal is sometimes represented wearing a human mask. This alert, curly-tailed dog has a burnished slip with badly eroded surface. Length 20.3 cm., height 19.1 cm.

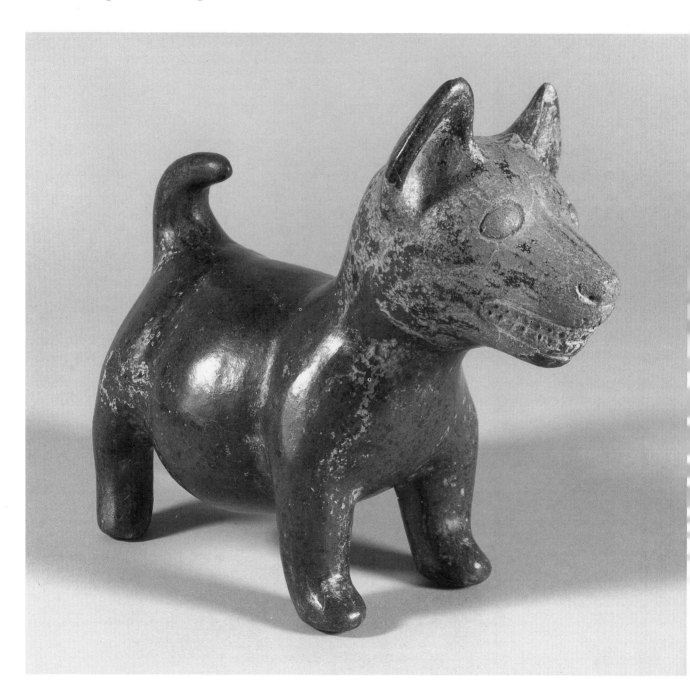

The Ancient Art of Colima, Mexico

68.

"Escuintle"

Pointed ears, fat belly, incised teeth, and spout.
Length 20 cm.

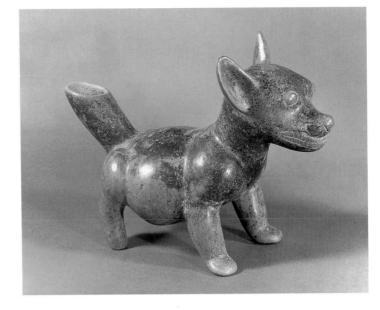

69.

Large Howling Dog

Length 63 cm., height 43 cm.

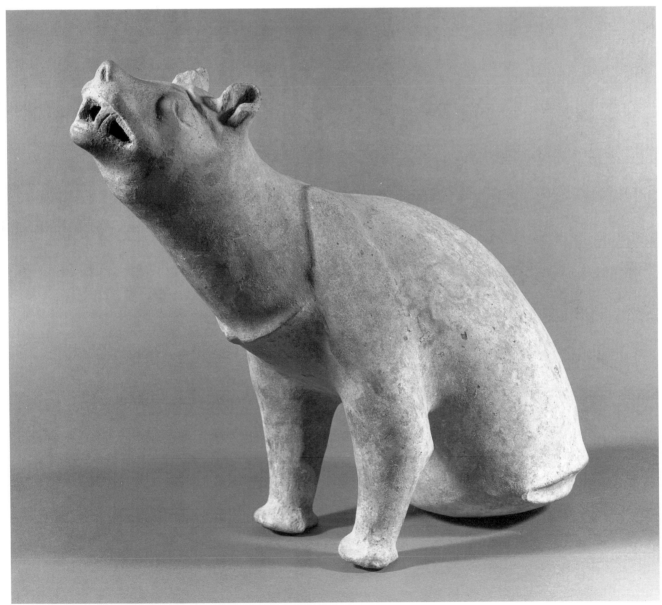

70.

Dog

Dog Scratching fleas with
molded wrinkles.
Height approximately 15 cm.

71.

Snarling Dog

Burnished red slip. Incised
paws, eyes. Height 16 cm.
Length 23 cm.

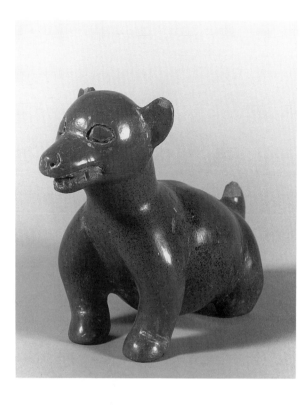

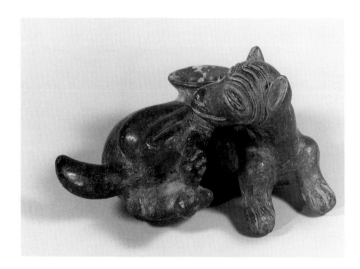

72.

Sleeping Dog

Scoop ears, spout.
Burnished red with
firing clouds.
Length 30 cm.
Height 11 cm.

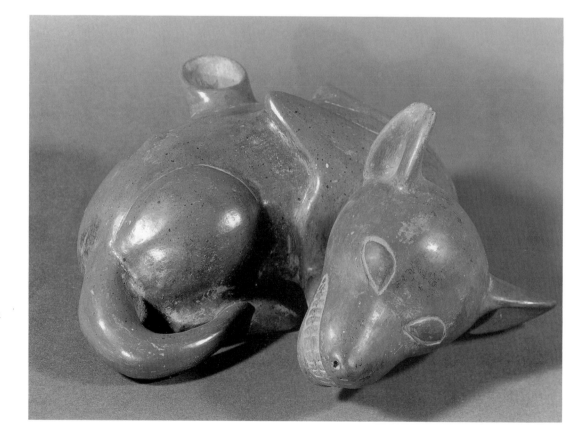

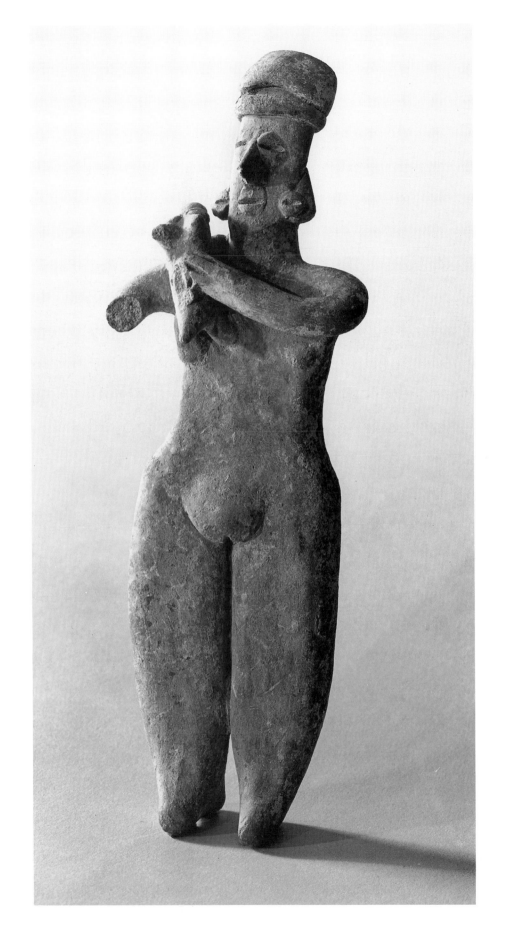

73.

Woman with Dog

A Tuxcacuesco-Ortices styled figurine depicting a female holding a dog. The woman is naked except for earrings and turban. Approximate height 14 cm.

74.

Coati Eating Corn

Burnished red with incised decoration. Spout tail. This piece is currently on display at the Museo de Las Culturas de Occidente, and is similiar to figure 151 in the Stafford Collection (Kan 1989:151). Approximate length 20 cm.

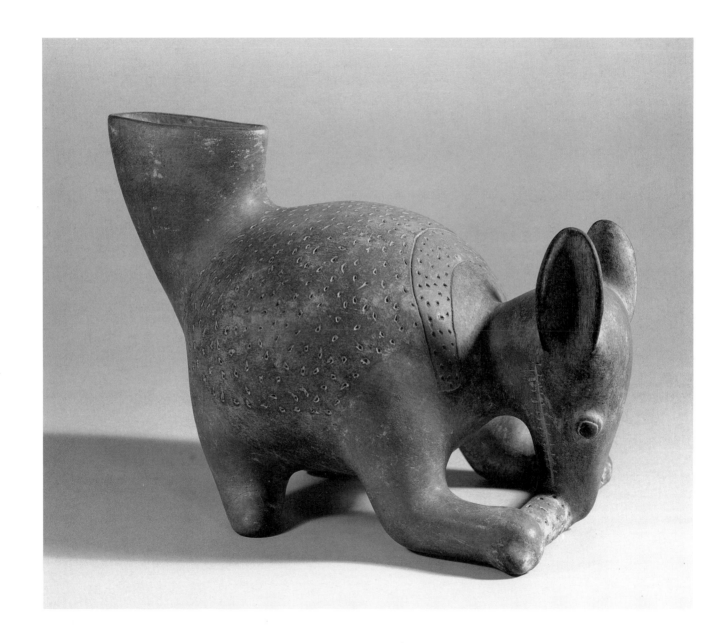

75.

Jaquar with incense burner

This piece was reportedly found in Ixtlahuacán.

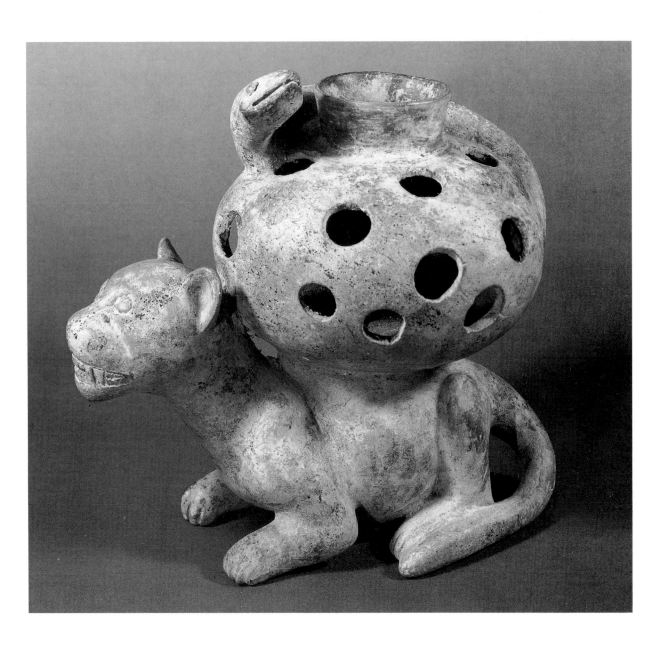

The Ancient Art of Colima, Mexico

81

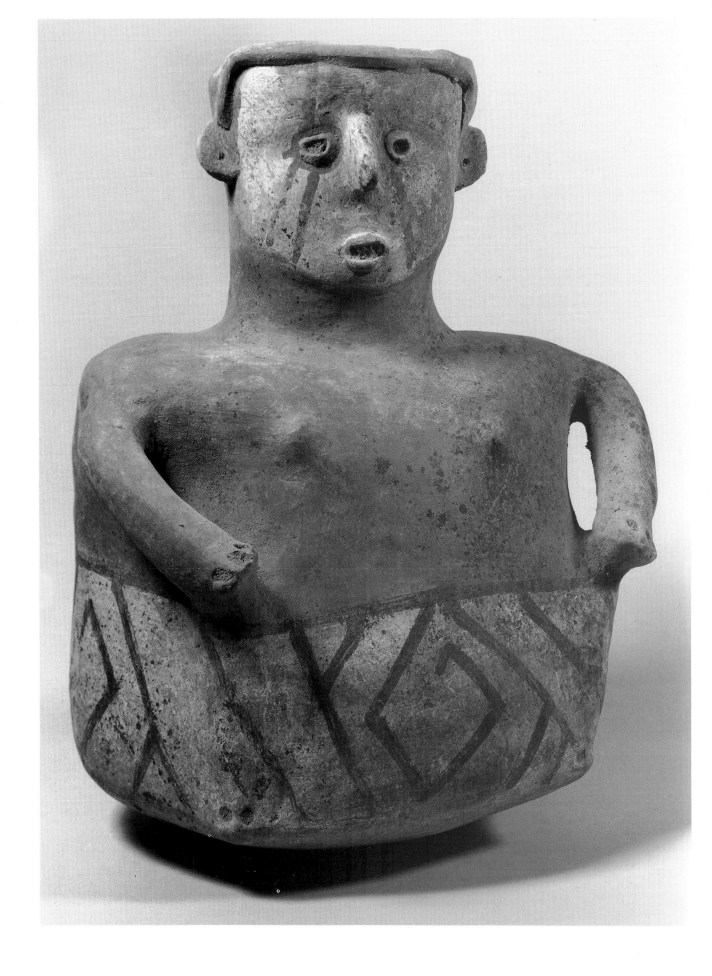

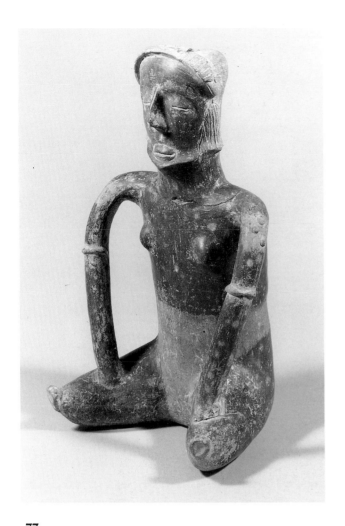

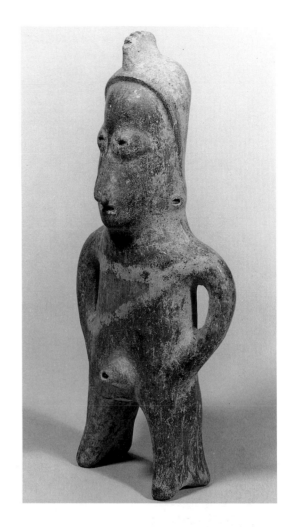

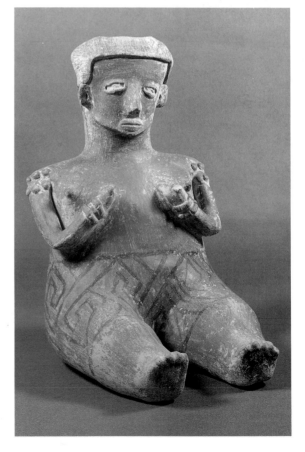

77.

Figure with String Arms

Cream decoration, with breechcloth on polished, dark red burnish. Similar to Kelly (1949: 275 plate 27b). Height 37 cm.

78.

Standing Figure with Crested Helmet

Similiar to a piece purchased by Kelly (1949: 273 Plate 26 g) from Tuxcacuesco, Jalisco, in the ancient province of Amula. This region was once part of what Sauer calls "greater Colima." Height 28 cm.

79.

Seated Figure

Seated figure with hands molded into the body. Shoulder pellets. Red burnished with black decoration. Approximate height 28 cm.

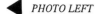 *PHOTO LEFT*

76.

Bowl Figurine

White paint over red slip.
Height 30 cm., orifice 10 cm.

80.

The Beggar

This unusual and interesting free-flowing figurine is made from fired clay with traces of black and white paint. Courtesy Doña María Ahumada de Gómez. Approximate height 12 cm.

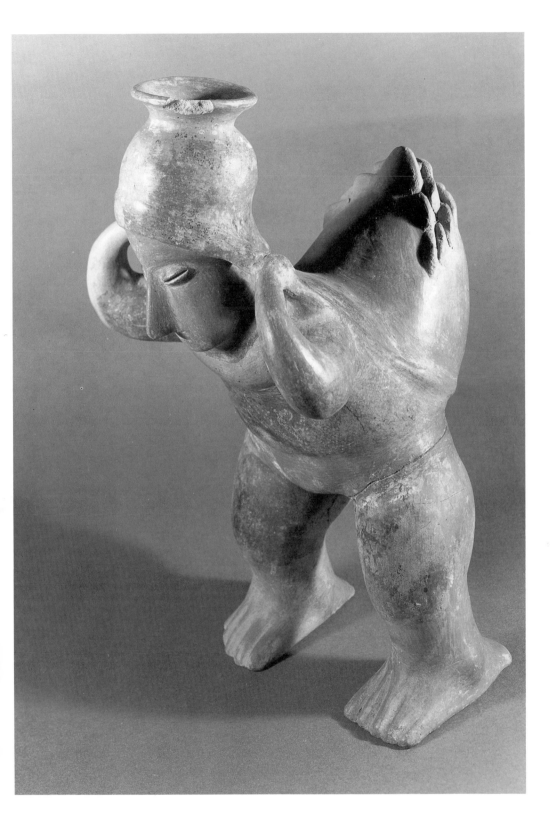

81.

Figure Carrying Fruits

Carrying burdens using a tumpline is an ancient practice common in both West Mexico and South America, but Hasso von Winning (1974:36) believes tomb art from Colima may represent the earliest evidence of tumpline useage in Mexico. Burnished red and orange slip. From the Doña María Ahumada de Gómez Collection. Height 35 cm.

82.

The "Singer"

With elbows bent and
hands aloft, figures
such as this from the
southern flank of the
Volcán de Colima have
been compared to the
"smiling faces" of
Veracruz and may
have been a female
representation of *Xipe*,
a water god. This
repaired piece was
reportedly found near
Cuahtemoc, and may
date from the Post-
classic, A.D. 900—1500.
H. 63 cm., W. 39 cm.

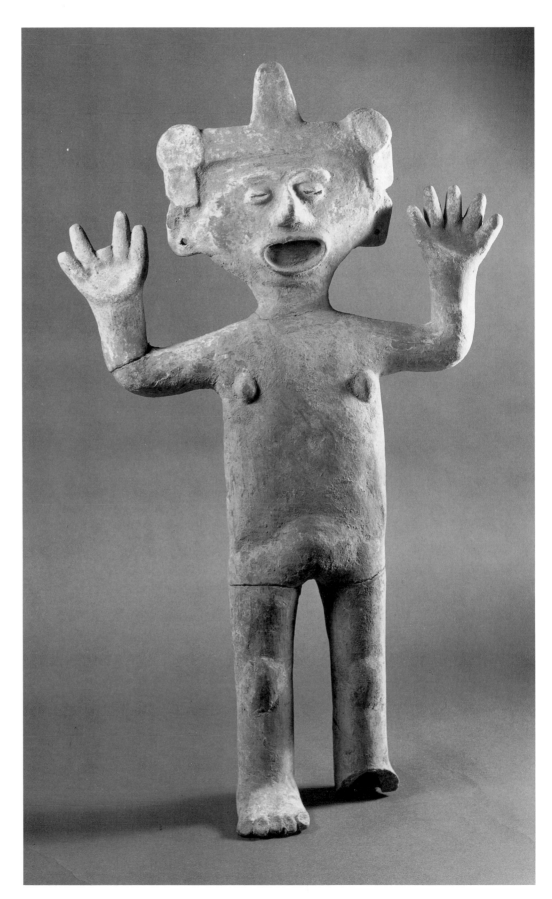

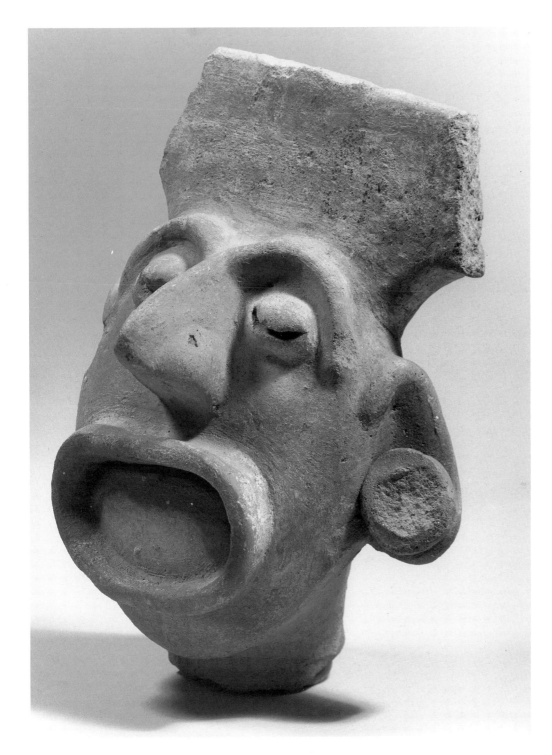

83.

"Xipoidal" Head
With Headboard.
Gray-green decor
on partial buff.
Height 19 cm.

The Ancient Art of Colima, Mexico

84.

Two Tecoman Figurines

Woman holding child.
Man with headdress and
armbands. Most figurines
from Tecoman have this
very distinctive nose con-
figuration, which Carolyn
Baus Czitrom has clas-
sified "Tipo XX, Figurilla
Periquillo, Nariz Ador-
nada," (1978:110).
Circa A.D. 1200.
Height 19 cm.

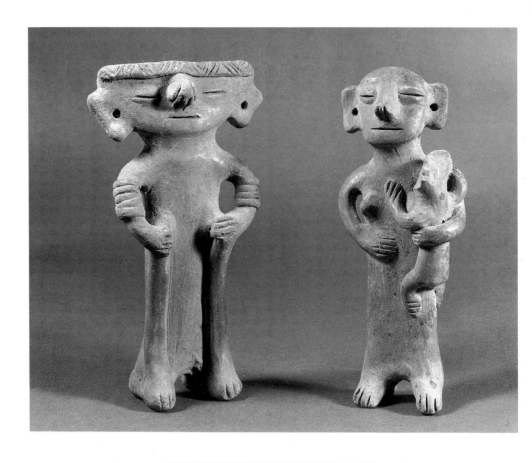

85.

Woman on Stool

This unslipped red figurine was reportedly
dug up near the main plaza in Tecoman
during a pipeline excavation.
Height approximately 18 cm.

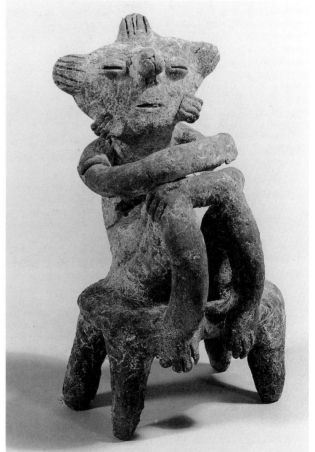

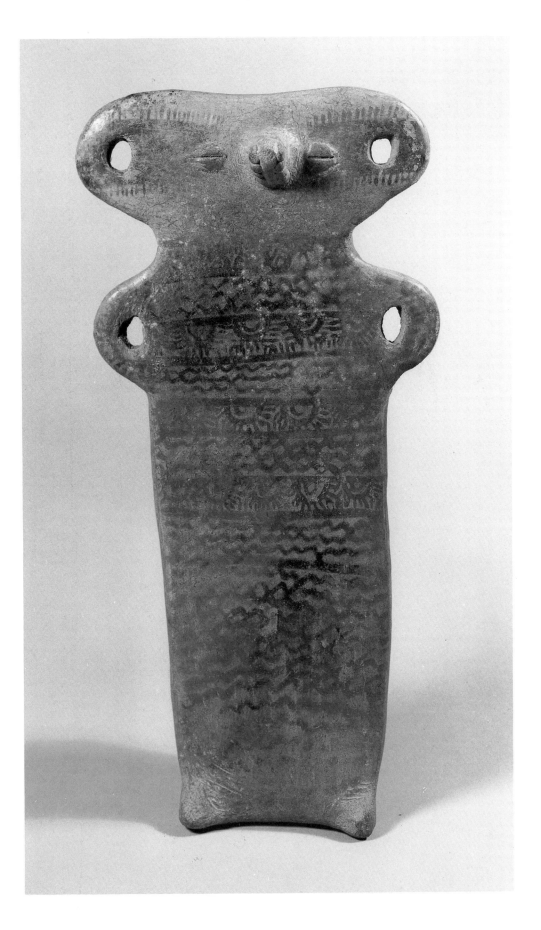

86.

Tecoman Figure

Dr. Isabel Kelly, the renowned West Mexico archaeologist, reportedly photographed this piece during the 1960's, and it may have been published elsewhere. Height 38 cm.

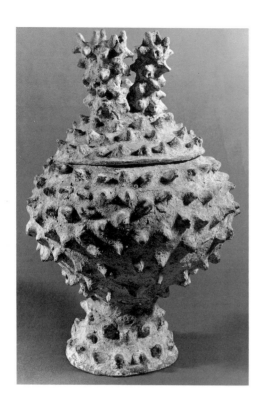

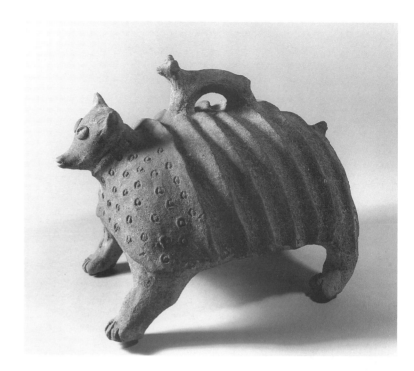

87, 88, 89 *Urns*

87.
Tall, spiked urn
Approximate height 30 cm.

88.
Armadillo Incense Cover
Height 17 cm.

89.
Spike-Covered Urn
Spiked urn reportedly found in the El Chanal region. Approximate height 27 cm.

PHOTO OPPOSITE PAGE

90.
Large Bowl Figure
Height 29 cm., width 20 cm.

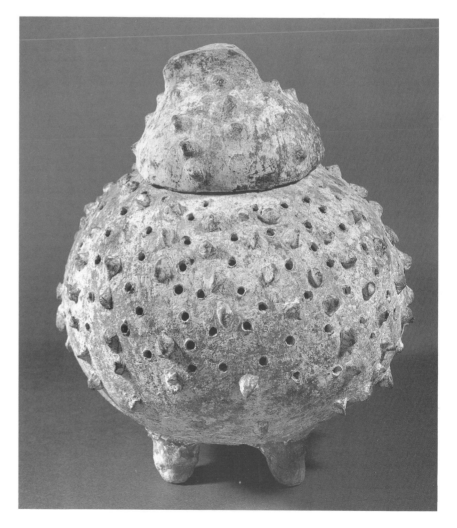

The Ancient Art of Colima, Mexico

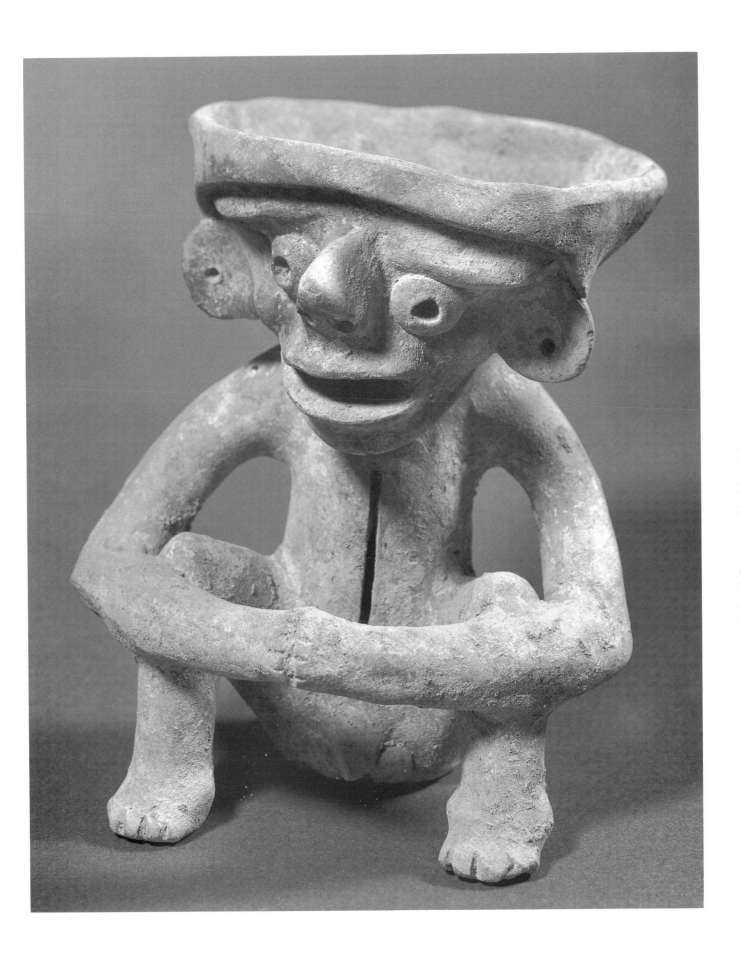

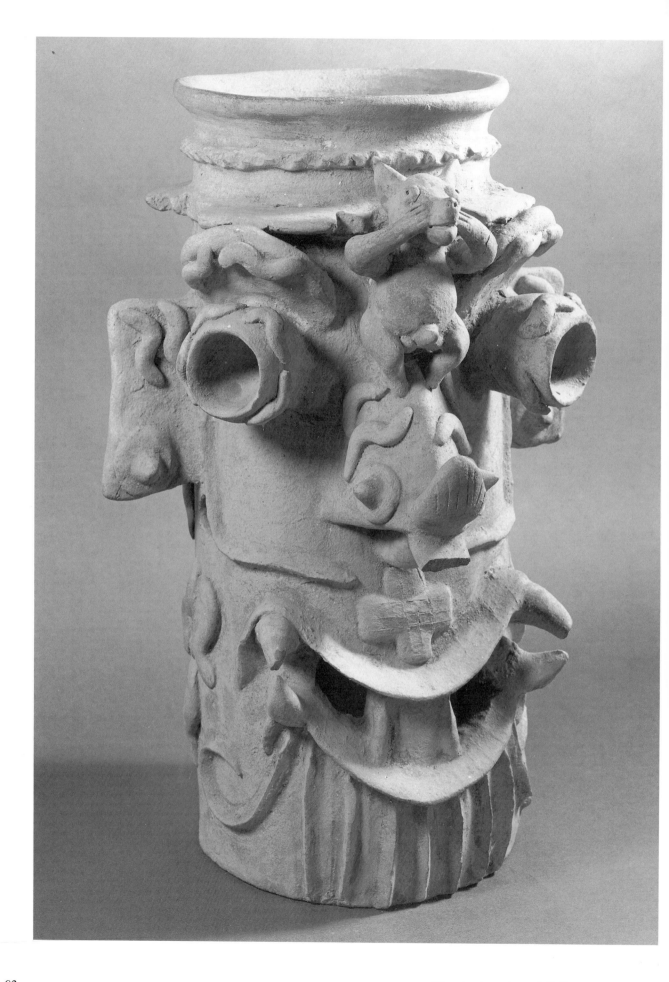

The Ancient Art of Colima, Mexico

91.

Large Clay Incense Urn With Howling Animals and Snakes

This large, bottomless cylinder, or urn, was reportedly "excavated" from the El Chanal cemetary upstream from Colima and was purchased from moneros by Doña María Ahumada de Gómez.
Height 43 cm., width 30 cm., diameter 19 cm.

92.

Molded Figure on Three-Slab Base

Height 22 cm., width 15 cm.

93.

Molded Figurine

Flowering headdress. Earrings. Pendent. Legs folded. Approximate height 11 cm.

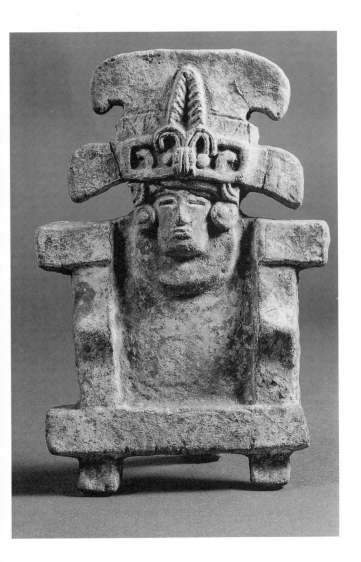

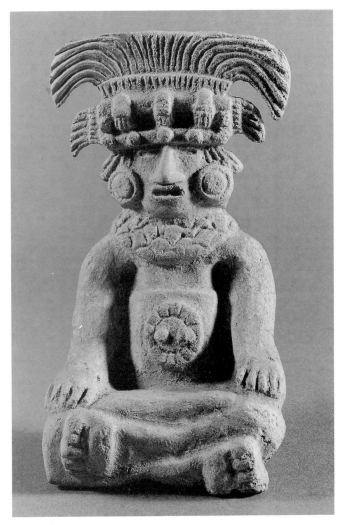

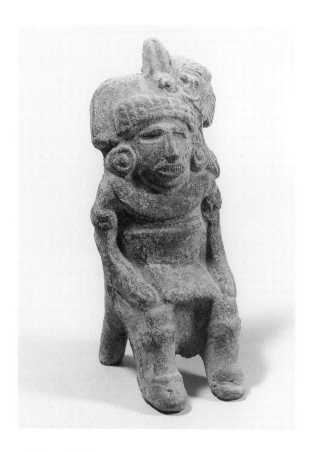

94. *Molded Figurine on Chair*

Height 15.2 cm., width 7 cm.

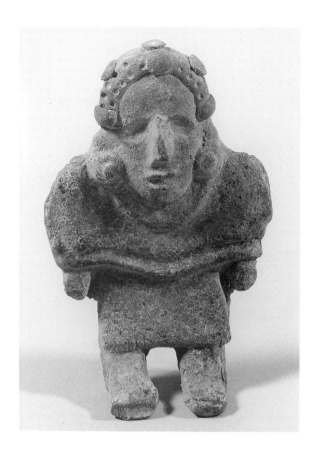

95. *Standing Mold Figurine*

Height 14 cm., width 9.8 cm.

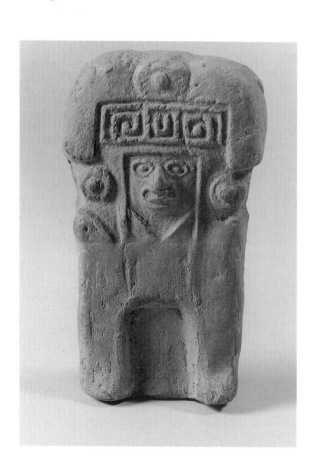

96. *Small Handmolded Figurine*

Reportedly found at Laguna Alcuzahue, near Tecoman. Height 9.5 cm.

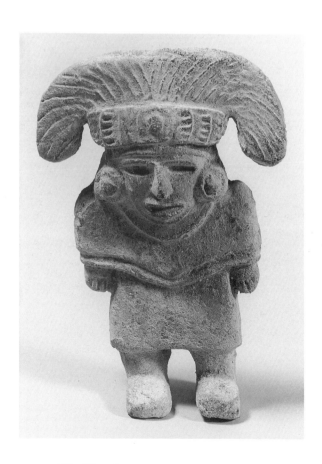

97. *Figurine*

Height approximately 10 cm.

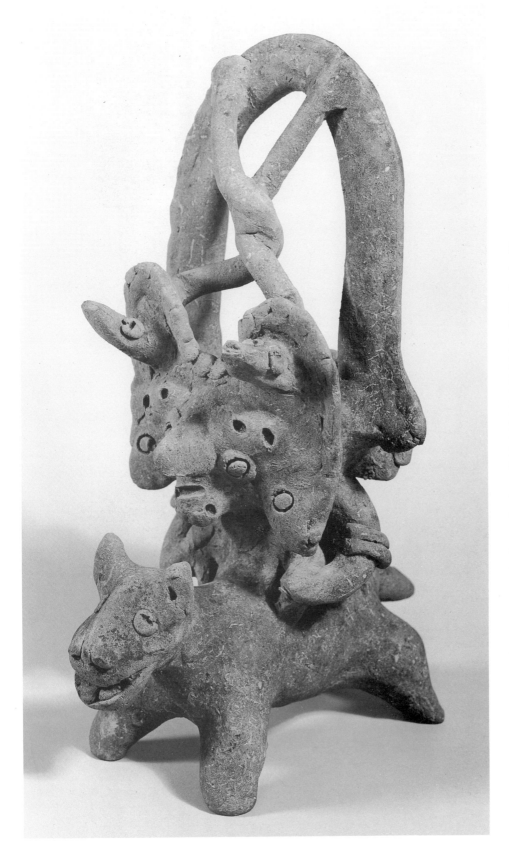

98.

"Tlaloc" Incensario

This incense urn was reportedly found in a tomb on the eastern slope of the Volcán de Colima, in the vicinity of El Chanal. The cemetary at El Chanal was the only known site in Colima with remnants of what might have been a pyramid and a ball court. Kelly reported radiocarbon dates at El Chanal as recent as A.D. 1460, and believes the site was abandoned by the middle of the fifteenth century (1980:13). The *Tlaloc* or rain-god figure of Colima is generally double-faced, with one male and one female riding back-to-back atop a galloping jaguar. The two-headed serpent, known as *maquizcoatl*, or bracelet snake, intertwine and combine rain, earth and fertility symbols connected to incense burning in Meso-america. There is a similiar *canasta*, or basket piece, in Proctor Stafford's collection (1989:172).
Postclassic, A.D. 900—1500.

Photo by Albert F. Reynolds

BIOGRAPHY :: Richard Derby Reynolds has traveled extensively throughout Mexico, and is especially familiar with the pre-Columbian art of Colima, on the western coast of Mexico. Although a passionate collector himself, Reynolds was disturbed by plunder of the ancient tombs of Colima, and he eventually returned to Colima and photographed dozens of private collections, ranging from simple fertility idols to elaborate, museum-quality tomb offerings. The resulting catalog depicts the artistic imagination of this unique, ancient culture and documents the flow of burial art as it moves from the tombs in western Mexico to the affluent art galleries of New York, Paris and Toyko.

Reynolds has worked as a journalist, and has also produced a number of films, including *Mudflat Art,* about driftwood art sculptures along the San Francisco Bay. In 1987, Reynolds published a nonfiction crime tale, *Cry For War, The Story of Suzan and Michael Carson.* This book was followed by *Squibob, An Early California Humorist,* a historical look at the author's distant relative, Lt. George "Squibob" Derby.

Reynolds currently lives in Antioch, California, with his wife and three children.